IMAGES
of America

SNOWFLAKE

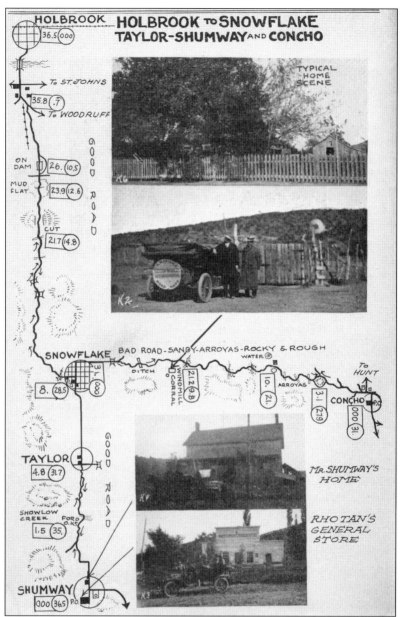

This 1913 Arizona Good Roads Association map was illustrated with photographs of a "typical home scene" in Snowflake (top) and the association's automobile stopped at a windmill and corral east of Snowflake. From Shumway (bottom) is Charles Shumway's home and Jasper Rhotan's general store. Joseph City is 10 miles west and Zeniff was 15 miles southwest of Holbrook. (William E. Ferguson.)

ON THE COVER: In towns across the West, 24th of July parades memorialize the Mormon pioneers entering the Great Salt Lake Valley. In the 1960s, the Snowflake parade always included John Ballard's truck carrying children riding in swings. Each year, more children in swings were added until 100 children were riding in the parade. For the bicentennial in 1976, the float included the sign, "200 Years of Freedom: Ringing and Singing." (Photograph by Max Hunt.)

IMAGES
of America

SNOWFLAKE

Catherine H. Ellis

ARCADIA
PUBLISHING

Published by Arcadia Publishing
Charleston SC, Chicago IL, Portsmouth NH, San Francisco CA

Printed in the United States of America

Library of Congress Catalog Card Number: 2007935836

For all general information contact Arcadia Publishing at:
Telephone 843-853-2070
Fax 843-853-0044
E-mail sales@arcadiapublishing.com
For customer service and orders:
Toll-Free 1-888-313-2665

Visit us on the Internet at www.arcadiapublishing.com

To Max Hunt, who believed the most interesting photographs were those depicting everyday life.

CONTENTS

ACKNOWLEDGMENTS

With the Mormon penchant for saving family stories, photographs, and artifacts, a treasure trove of information is available (although usually in local homes). I am particularly grateful for all who shared photographs (as credited). I also used photographs from the Arizona Historical Society at Tucson (AHS/Tucson); Navajo County Historical Society in Holbrook (NCHS); Arizona State Library, Archives, and Public Records (ASLAPR); and Arizona Historical Foundation (AHF). Photographs without notations are from the author's collection. Notes on information sources are deposited with the Taylor Museum.

Of particular note are a series of photographs at the Arizona Historical Foundation that Milton Snow, an employee of the U.S. Indian Service in Window Rock, took in 1936 of Snowflake, Taylor, and Shumway. These photographs inspired a goal of 80 percent never-before-published images. The goal was probably not met, but I hope all who are interested in northern Arizona Mormon history will enjoy my selection.

This book covers more than just the history of a single town. The Images of America series uses place names without subtitles, and it was simply not possible to list all the towns influenced by Mormon colonization in Navajo County. The Snowflake Stake (similar to a diocese) included ecclesiastical units from Joseph City to Lakeside (and in the late 1800s included towns as far west as Flagstaff). Snowflake Stake became the center of Mormon activities. Also a single event often influenced several towns. For example, when the Curtiss biplane landed in Snowflake in 1921, the newspaper noted, "The appearance of the machine in Snowflake created more excitement than a circus and the schools here and at Taylor almost quit business for a time." Finally, the Snowflake Stake Academy was a unifying presence and attracted students from all outlying communities.

Many people deserve my thanks, especially John Taylor, president of the Snowflake Heritage Foundation; Carmen Shumway of the Taylor/Shumway Heritage Foundation; Arvin Palmer; and Karina Wilhelm. Dr. Jack August, Jared Jackson, and Christine Talbot at Arcadia were most helpful, although Christine's first comment was, "Where do we sell this?" I believe she will be pleasantly surprised at the interest in Snowflake's history.

INTRODUCTION

"Snowflake, Taylor, Shumway, Three Prosperous Towns," is the title of the entry in Harry Locke's 1913 *Arizona Good Roads Association Illustrated Road Maps and Tour Book*. For $2, a person could purchase this "first book of road maps and touring information ever published in Arizona." Locke described Snowflake as "a thriving farming and stock-raising town of about 750 inhabitants. . . . Three crops of alfalfa are raised in a season, and 40 bushels of wheat or 75 bushels of oats to the acre are not uncommon. Some fine openings for settlers of the right type lie right at our doors merely for the taking." He noted that Snowflake had a bank, three general stores, three good hotels, one restaurant, two barbershops, two livery and feed stables, a high school, a district school, a church, and "a fine Opera House." Finally, Locke mentioned the anomaly of a Mormon (Church of Jesus Christ of Latter-day Saints [LDS]) town in the West: "Although the town has been settled for over 24 years it has the distinction of never having a saloon within its boundaries."

Snowflake's Mormon history began with the 1878 purchase of the James Stinson ranch on Silver Creek, which 20 miles downstream contributes to the Little Colorado River. William J. Flake pledged $11,000 in cattle for the ranch. Flake then opened the area up for Mormon settlement. Snowflake received its distinctive name from combining his name with the name of Erastus Snow (a Mormon apostle who supervised Arizona colonization).

Soon a small community flourished, determined to be a bastion of culture in an area typically thought of as the last of the Wild West. A church-sponsored academy (high school) provided education for children from the surrounding communities. Dances, plays, and musicals were produced for the enjoyment of all. Most spectacular were the pageants presented north of town at the Sinks. These unusual geological features are collapsed caverns in the Kaibab Limestone. They provide natural amphitheaters large enough for horses to be used in the productions. From 1913 to 1915, Snowflake even hosted a National Guard unit, Company F. Only one other such unit was active in northeastern Arizona (Company K in St. Johns, 1893–1902). Both were disbanded when membership fell below strength.

Taylor, three miles to the south, also sprang into existence in 1878, mainly through the efforts of James Pearce and John Henry Standifird. Pearce built a dugout for his family that first winter, and good crops were raised by irrigation from the clear, cold creek. Tradition has it that Pearce planted peach and plum pits the first year and that some of the trees still produce fruit. For his Good Roads Association map, Locke described Taylor as "a town of about 500 inhabitants 3 miles south of Snowflake. Taylor has two hotels, and two general stores." He stated that "Shumway, 7 miles south of Snowflake, is a noted fruit district growing apples, peaches, pears, grapes, plums, and all kinds of vegetables in abundance. It has a general store and a hotel." Today Taylor celebrates both its national and pioneer heritage with Fourth of July festivities.

St. Joseph (now Joseph City) and Woodruff also contributed to this Mormon enclave. Both towns are located on the banks of the Little Colorado River and illustrate the persistence of early pioneers in harnessing the waters of this ephemeral stream. Dam after dam was constructed and then washed out during summer thunderstorms. At the dedication of the eighth dam in

1894, Andrew Jensen, LDS Church historian, complimented Joseph City for being "the leading community in pain, determination and unflinching courage in dealing with the elements around them." This dam was of sufficient engineering that it lasted until September 1923, when torrential floods carried away dams upstream.

Although these towns were originally settled by Mormons, the construction of a pulp and paper mill west of Snowflake and the Cholla Power Plant east of Joseph City in the 1960s forever changed their makeup. Other churches were soon constructed (for example, Our Lady of the Snows Catholic Church and a Baptist church were the first in Snowflake); descendants of the original pioneers and the newcomers experienced some difficulties learning to work together. In the 1970s, Rev. Bill Kelley, a Baptist minister, helped both groups connect. He owned two cannons and persuaded a group of Snowflake men to join him in taking the cannons, along with a team of horses and a covered wagon, to parades in Wickenburg and Phoenix. He placed a sign, "U.S. Headquarters 6th Cavalry and Artillery, Snowflake Garrison, Arizona Territory, U.S." over the door of a small red sandstone building, although no such unit was ever stationed in Snowflake. The sign has since been removed.

In the 130 years since the original Mormon pioneers came to northern Arizona, so many changes have occurred that these pioneers would no longer recognize their towns. Some towns have grown; others have remained small. The first years were times of starvation because little food was grown; today food is shipped in from all corners of the world. These towns, however, have not forgotten the original settlers. In 1922, when James Pearce died, Marion L. Tanner eulogized him with this verse, which applies equally well today:

> One by one that stalwart band,
> Who braved and fought an untamed land,
> Where drought and flood and wind and sun
> Warred with each other since time begun, . . .
> Thanks to them, the pioneers,
> Who carved and wrought thru trying years;
> Who paved the way, subdued the flood,
> And built a state with brawn and blood; . . .
>
> One by one that stalwart band
> Are passing to a kinder land.
> Their stooping frames, their graying hair,
> Betoken years of stress and care.
> May we who reap where they have sown
> Guard and treasure our very own—
> The priceless heritage of earth,
> The land that gave these heroes birth.

One

THE EARLY SETTLERS

In the mid-1960s, Hy Barrett of Pocatello, Idaho, stood in Max Hunt's living room in Snowflake, and, looking out the picture window toward Cottonwood Wash, opined, "Brigham Young must have made a mistake sending pioneers to this desert." Without a break in rhythm, Hunt countered, "Brigham Young sent his very best pioneers to this area."

Brigham Young may or may not have sent his best pioneers to Arizona, but those who remained were certainly hardy. Woodruff was the smallest, most precarious Mormon community along the Little Colorado River, and the Little Colorado River settlements were perhaps the least hospitable of more than 350 Mormon settlements from Canada to Mexico. Charles Peterson wrote about Woodruff, "From the first, settlers appear to have vacillated about the desirability of staying."

Even today, the coarse red sand blows through northeastern Arizona streets every spring. Della F. Smith, a daughter of historian Joseph Fish, was one of the sturdy pioneers who stayed. Her poem "Snowflake's Sunset," published in the *Snowflake Herald* March 25, 1921, notes both the beauty and the hardships these pioneers found in northeastern Arizona.

> Had you but seen
> The setting sun on Snowflake hills
> And felt the grandeur it instills,
> Like one great dream,
> You'd know the Gods had done their best
> To show their skill along the west.
> The sky is blue, the clouds are white
> To lend a charm of mellow light,
> Then dashes of a golden red
> Along the horizon are spread.
> In all the world there cannot be
> Another sight so fair to see;
> For Nature placed the colors grand
> As recompense for wind and sand.

Although not the first settler, William J. Flake was, as described by Joseph Fish, "a great hand to trade." When the Mormon settlers wanted to purchase acreage for a ditch at Shumway, Jesse N. Smith requested that Flake make the purchase, which he did within a few days. Flake purchased land in both Navajo and Apache Counties, which he resold to Mormon settlers without profit. (AHS/Tucson No. 4980.)

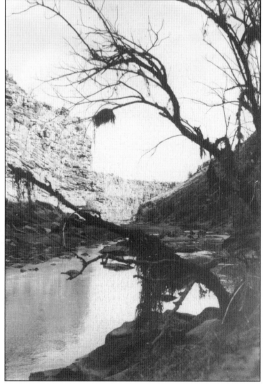

"Silver Creek," wrote Kenner Kartchner, "trickles down through Snowflake Valley from its source at Silver Spring, which gushes out from under a malpais (basalt) ledge, some fifteen miles to the southeast. It never varies the year round and furnishes irrigation for several thousand acres [sic] of tillable land." Albert Levine photographed Silver Creek at the entrance of the canyon just north of the town around 1940 and shortly after a flood (note debris in the tree).

In 1879, Joseph Fish was appointed justice of the peace. His first official business was in Taylor when he performed the marriage of James Stinson and Margaret Melissa Bagley, a Mormon girl who had three children from a polygamous marriage but left her husband and came to Arizona with her parents. Stinson moved his family to the Tonto Basin, Salt River Valley, and then to Colorado, from where they returned in 1928 for this reunion photograph with William J. Flake (right). (Wanda Smith.)

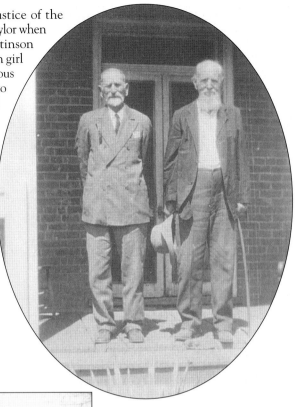

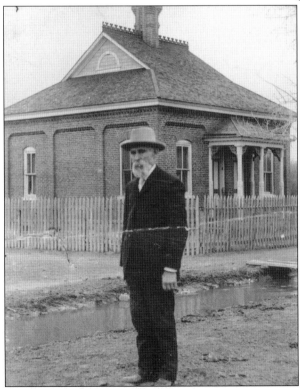

John Hunt was called by Brigham Young in 1877 to "join Bro. Lot Smith at the Little Colorado" or "go to the brethren who are laboring with or near the Zuni Indians." Hunt chose to go to New Mexico, where the family lived a year before he was called as bishop of the Snowflake Ward. He served for 31 years and is pictured here in front of the tithing office. (Louise Levine.)

Jesse N. Smith came to Snowflake in 1879; others in his party included John Hulet, Smith Rogers, Silas Smith, John A. Smith, Amos Rogers, Cornelius Decker, John Rollins, Lehi West, and Joseph Fish. Jesse N. served as president of the Eastern Arizona Stake and later Snowflake Stake until 1906. George Crosby Jr. from St. Johns named Smith as one of the two most important Mormon men in the settlement of Arizona (with Christopher Layton). However, Smith's first concern was his large family, some of whom are shown below in front of their log cabin. As Joseph Fish wrote, "The life of a pioneer is a hard one but it is mingled with rays of light and joy in seeing the waste places made to blossom, and house and gardens take the place of sagebrush that covers the deserts." (Both, Smith Memorial Home.)

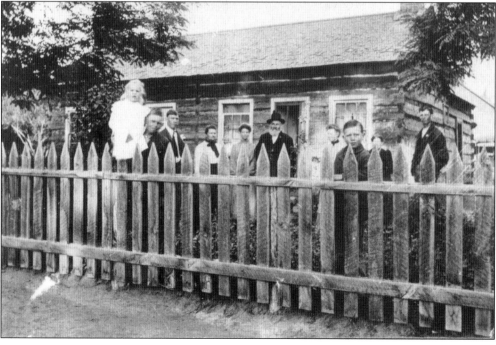

Jane Casner and her sons came to northern Arizona from Oregon before 1875 and settled between Flagstaff and Winslow. The sons worked hard, and in July 1876, the sale of lambs and wool netted them $6,300 in $20 gold coins. Unfortunately a hired hand, William Clancey, tried to steal the money, and, in the chase that ensued, the buckskin bag containing the coins fell from the saddle and was lost. Neither the Casner brothers nor Clancey nor numerous treasure seekers could find the bag. Six years later, Andrew Locy Rogers (pictured above in 1912) stumbled upon the coins as he was trailing sheep. He immediately notified the Casner brothers, and they "gave me ten pieces of gold," said Rogers. "I paid my tithing to the church, gave my father $100 and $40 to my wife's mother. With the remainder, I bought a Winchester rifle and the balance went to buy baby clothes." Rogers became known as the Abe Lincoln of Snowflake. (AHS/Tucson No. 1602.)

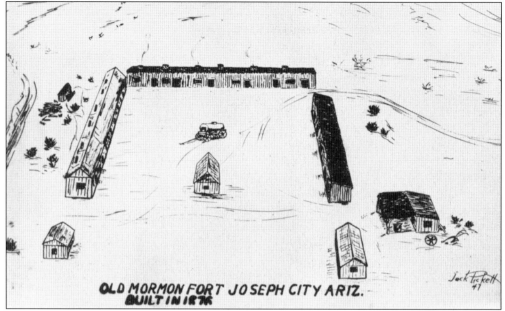

The first Mormon wagon companies arrived in 1876 and settled along the lower Little Colorado River. Forts were constructed; Obed, Brigham City, and Sunset (from approximately Winslow to Joseph City) probably never had private homes. Joseph City and Woodruff also began with forts, which were especially useful when the settlers were cooking and eating together. This fort at Joseph City was probably used longest. (Drawing by Jack Pickett.)

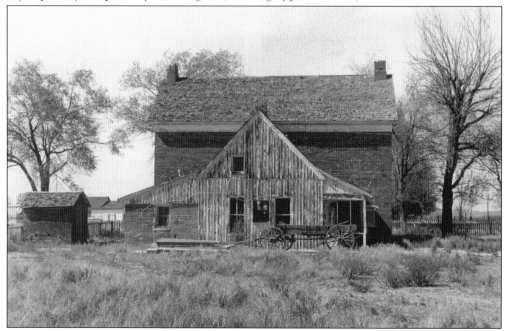

John Bushman built this frame house in Joseph City first and then the brick home (attached and actually in front). He fired his own bricks and made his own nails. Parked by the house is the ubiquitous covered wagon (sans cover) photographed around 2000. (Photograph by William E. Ferguson.)

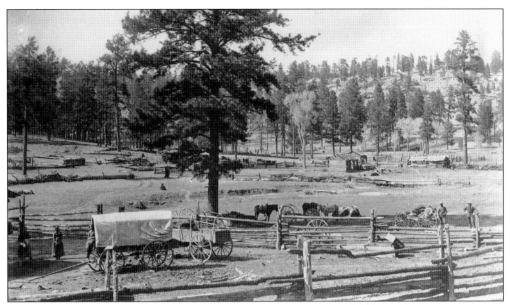

Edward W. Kinsley was a railroad executive who also had connections to the Aztec Land and Cattle Company. He left an album with early (c. 1886–1888) photographs of Snowflake, Shumway, Taylor, Holbrook, and Heber. This photograph is of a ranch at Wilford (west of Heber). John Bushman and others from Joseph City settled Wilford in 1883. Insufficient water led them to abandon the town. (ASLAPR No. 03-1369.)

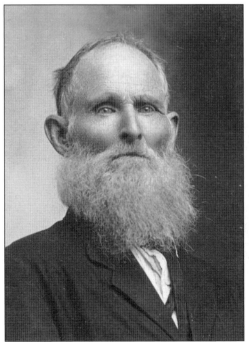 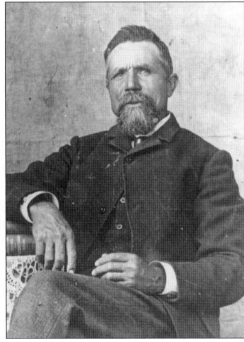

John Henry Standifird of Taylor (left) and Albert Minnerly of Snowflake (right) were two early settlers. Standifird came to Taylor in 1878 with his 13-year-old daughter, Ann, planted crops that summer, and then returned to Utah for the rest of his family. Minnerly kept a hotel in Snowflake where Fort Apache officers often stayed. (Both, Shirley Cole.)

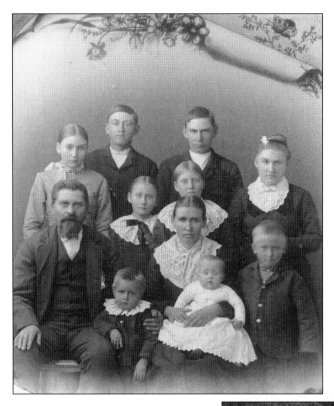

Taylor settlers were advised to build on only one side of Silver Creek, but with good land on both, they ignored the advice. James and Mary Jane Meeks Pearce settled in Taylor; Mary Jane was a licensed midwife, delivering over 100 babies. James was involved in all aspects of the community. When irrigation water was in short supply and tempers a bit short, he defused the situation by asking, "Would the good brethren of Snowflake mind if Taylor did some dry farming?" (Shirley Cole.)

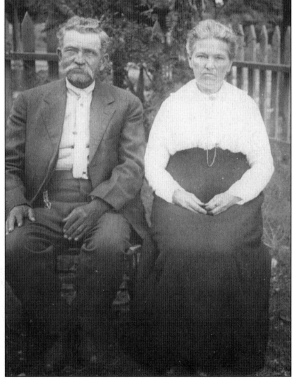

Alma Zemira (A. Z.) and Alzada Palmer came to Snowflake with William J. Flake. A. Z. Palmer and Mark Kartchner began the first store in Snowflake, but Palmer moved his operation to Taylor in 1895 (later the Hatch store and now Taylor Museum). He was remembered in a Taylor centennial poem: "A. Z. Palmer ran a store in Taylor's early days. The children in town soon discovered how to profit by his ways. [Because] he never weighed or measured when it was candy they were buying." (Arvin Palmer.)

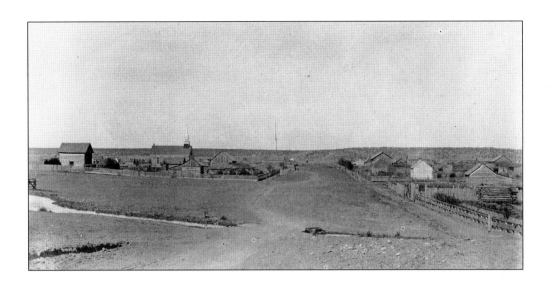

"One of the first things the Mormons always did in establishing a new settlement," wrote Frederick Dellenbaugh, who accompanied John Wesley Powell on his second trip through the Grand Canyon, "was to plant fruit and shade trees, and vines, and the like, so that in a very few years there was a condition of comfort only attained by a non-Mormon settlement after the lapse of a quarter of a century." Northeastern Arizona Mormon settlements were no exception. Beautiful shade trees lined the streets by the dawn of the 20th century. Above, Snowflake is photographed in the mid-1880s (from the E. W. Kinsley album); note a bowery by the church and a deer standing by the bridge over the ditch. Below is Ninian Miller's home around 1900. (Above, ASLAPR No. 96-2134; below, Leon Miller.)

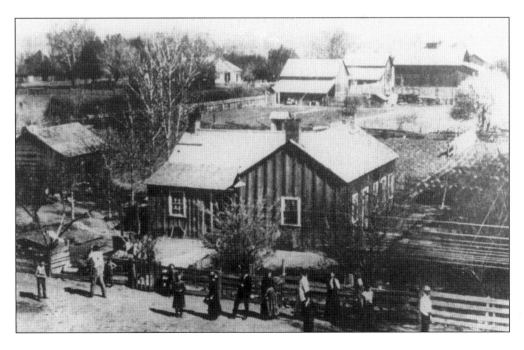

In E. W. Kinsley's late-1880s photograph of Woodruff, the large building is the Arizona Cooperative Mercantile Institution (ACMI), which, although originally in Holbrook, was moved to Woodruff in 1882 when the railroad bypassed the original site. Landowners at the new depot were not willing to sell to Mormons until after a disastrous fire in 1888. The store was then moved back to Holbrook. (ASLAPR No. 96-2133.)

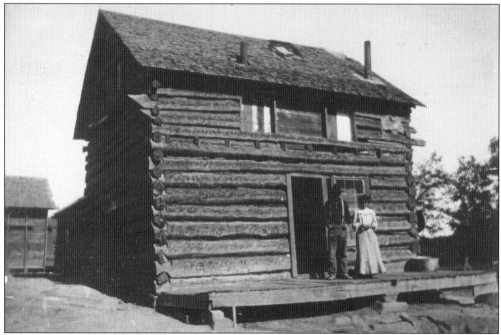

The first pioneer homes were constructed of ax-hewn squared logs with dove-tailed or half dove-tailed corners. The logs were chinked with mud or mortar. The Rogers log cabin in Snowflake was hidden within a later house and rediscovered when the house burned. This log cabin in Woodruff was the James D. Smithson home. Lon Savage and Effie Smithson are standing on the porch. (Morjorie Lupher.)

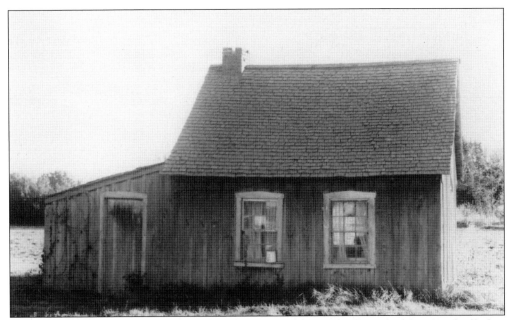

Hans Gulbrandsen built this house in Woodruff. After summer floods washed out Woodruff's first dam in 1878, he was one of only three men to remain. Morjorie Lupher wrote that Gulbrandsen's widow, Ingebor, drove her two cows "every day out on the hills to feed, then she would pick up sticks . . . on her way back home." In 1905, the property reverted to the LDS Church, and the house was demolished in the 1950s to make room for a new meetinghouse. (Photograph by Max Hunt.)

Only 13 families lived in Woodruff in 1880. In 1885, Gulbrandsen's daughter, Louisa Cross, traveled by train from Freeport, Illinois, with her four children. Arriving at the fort in Woodruff and discouraged by the poverty she saw, Cross slipped behind the fort so the children would not see her tears. She soon sought employment in Holbrook and boarded her children in Mormon homes. This image dates to around 1920. (Ruby Gibson.)

James William Gibson (left) was born in 1870 in southern Utah and orphaned by age five. He came to Snowflake with his brother-in-law Charles Ballard in 1880. As a teenager, he hired out as a cowboy, including riding "rough string" for the Aztec Land and Cattle Company, better known as the Hashknife for its distinctive brand. James's grandson Dale Gibson wrote, "When a cowboy would have a horse in his string that was too mean for him to ride, that horse was turned over to Grandad to break and train so the cowboy could handle him. He also broke new horses, from wild broncos to working cow horses." Below is an advertisement showing the Hashknife brand. (Left, Ruby Gibson.)

Ear marks, Crop right, underbit left,

AZTEC LAND AND CATTLE CO
(LIMITED)
Post office, Holbrook, Arizona. Range, Apache and Yavapai counties,

Old cattle branded on left side and hip Also in various other brands and marks.

 on both sides kept up.

Horse Brands: right or left shoulder. HS
right thigh.

James Thomas lived in Pinedale and is shown here with his grandfather Elijah Thomas's Mormon Battalion musket. Although the Mormon Battalion only marched through southern Arizona, several members later settled in northern Arizona. Those in Navajo County included Samuel H. Rogers, Sanford Porter, Wesley Adair, William A. Follett, and Marshall Hunt. (Arvin Palmer.)

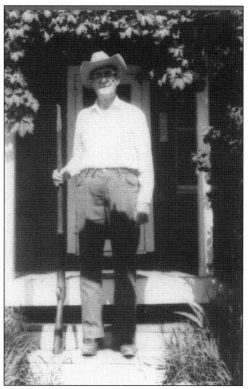

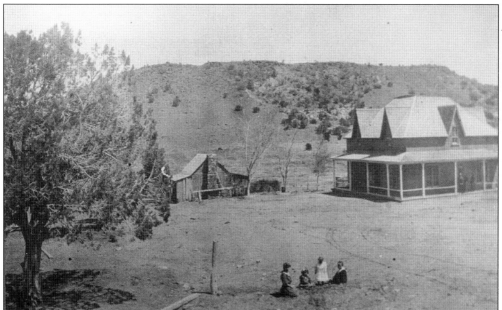

This photograph of the Solomon ranch in Shumway includes both the original cabin, built in 1878 by John Henry Standifird, and the house built about 1904 by Edwin Solomon. The children are (left to right) Flossie, Rilla, Bessie, and Rick Solomon. Ann Standifird Shumway remembered being particularly desperate for food when the creek was suddenly full of fish, which they caught in tubs. (Shirley Cole.)

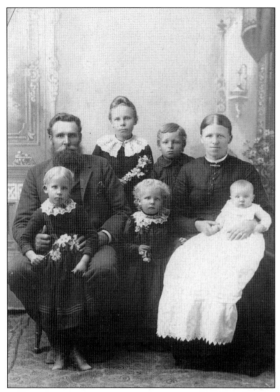

Joseph C. Hansen, one of the rugged and determined pioneers of Joseph City, arrived in 1878. Although he retained land in Utah for many years, his family became a stable part of the community. He liberally supported all worthy causes and was particularly instrumental in designing a dam that withstood the summer floods. In September 1908, he and John Bushman were honored delegates to the 16th National Irrigation Congress in Albuquerque, New Mexico. With Hansen's large family (above) of mostly daughters, sending sons on a mission was difficult. Instead Edna (below left with companion Mae Knutti of Montpelier, Idaho) served from 1916 to 1918 and May from 1925 to 1927, both in the Southern States. (Son James served in the Northern States from 1918 to 1920 after he was married and had three children.) (Below, Sarah May Miller.)

Nathaniel (or Z. N.) Decker was born in Parowan, Utah, and came to Arizona with his parents in 1879. He herded sheep, learned to cook and mend, taught school, and married Matilda Westover in 1896. After they had two children, he served a mission (from 1899 to 1901); the practice was then common of calling married men on missions. (Smith Memorial Home.)

In 1908, John H. Miller was working at the ACMI in Holbrook. One day, James M. Flake stopped in and, hearing some slang language from Miller that he thought inappropriate, said he thought Miller had better go on a mission. When the stake president wrote "asking how soon I would be ready to go," Miller's answer was two weeks. He served in the Northwestern States Mission. (Leon Miller.)

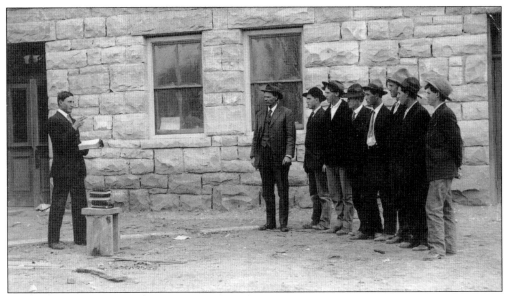

Joseph Peterson (in front of the window) spent many years as principal and teacher at the Snowflake Stake Academy and was elected county supervisor and superintendent of schools. He is photographed here with a missionary training class in 1917; Elias Smith is holding a book while honing his preaching skills before classmates. (Karen LaDuke.)

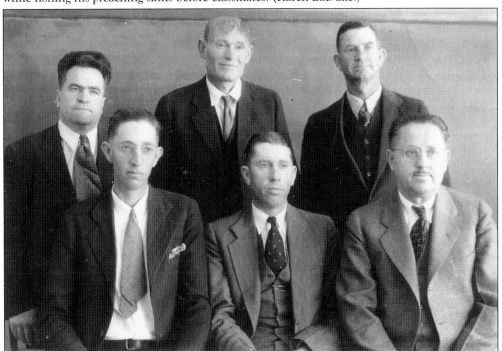

These home missionaries, photographed in 1937, include, from left to right, Martin Degan Bushman, Virgil Flake, Jesse Decker, S. Eugene Flake, William Ammon Morris, and Herbert A. Berry (from St. Johns). After World War II, Morris worked at Yellowstone National Park. Then, from 1951 to 1952, he worked at a dude ranch in Camelback where he was photographed with "Hop-Along-Cassidy" (William Boyd). (Arno Hall.)

This studio portrait of Joseph Sponseller was taken about 1885 (and has erroneously been published as William J. Flake). He is probably wearing clothing provided by the photographer. The long fringe on his pants would certainly have encumbered this sheep rancher and carpenter. Sponseller married Martha Louise Adams and lived in Taylor, Shumway, and Show Low until approximately 1920. (NCHS.)

Joseph C. Fish, an early Navajo County pioneer, made an extensive collection of southwestern pioneer histories. His journal and unpublished manuscripts have provided helpful information to many historians. Posing in bowler hats are, from left to right, Edward M. Webb (early educator), Silas Smith (son of Jesse N. Smith), an unidentified child, John L. Fish (son of Joseph), and Joseph C. Fish. (AHS/ Tucson No. 11028.)

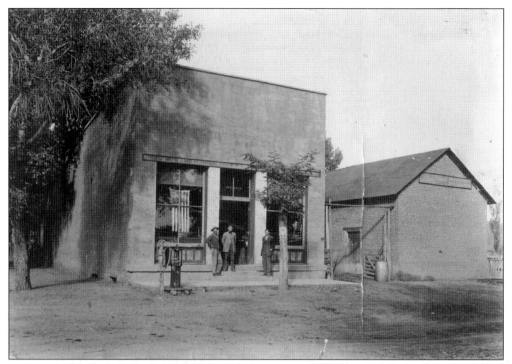

Patterned after Zion's Cooperative Mercantile Institution (ZCMI) in Salt Lake City, the ACMI was formed by early pioneers. Stores were located in Holbrook, Woodruff, Snowflake, and St. Johns. Samuel F. Smith is standing at the extreme left in front of the Snowflake store. Note the flag in the window and the sign over the adjoining building advertising Studebaker wagons and carriages. (Sarah May Miller.)

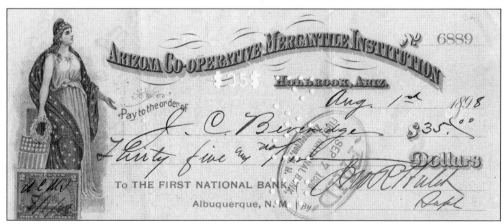

This 1898 ACMI draft was issued by John R. Hulet to J. C. Beveridge of Fort Apache. Beveridge endorsed it to the Post Exchange, and then George E. Mitchell, second lieutenant, transferred it to A&B Schuster of Holbrook. The ACMI hired many Mormon freighters to transport supplies between the Holbrook railroad depot and Fort Apache.

John R. Hulet is remembered as manager of the ACMI in Holbrook, but in 1908, he also tried to promote an automobile toll road from Holbrook to points south. Ultimately the project was abandoned, and upon Hulet's death, his son Ernest replaced him at the ACMI. In 1957, Ernest was postmaster and swore in the first Hashknife Sheriff's Posse as mail carriers. (Smith Memorial Home.)

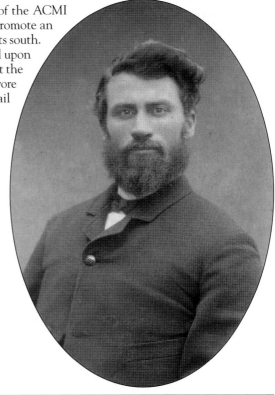

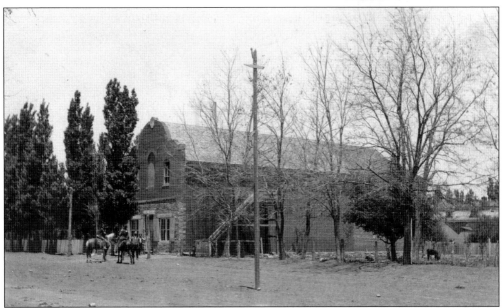

Brothers Charles and James Flake began this brick store in Snowflake in 1886. In 1892, they were involved in Snowflake's only shoot-out. While trying to arrest Billy Mason, Charles Flake was killed; Mason also died but was not mourned as was 30-year-old Flake. The building burned in 1912 and was rebuilt as a single story; in 1999, Dean and Sandra Porter restored the second story, complete with an outside stair to an assembly hall.

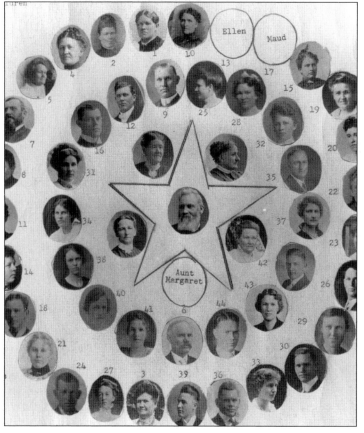

Many Mormons thought a polygamous marriage performed in Utah could not be prosecuted in Arizona. They were wrong. Every possible scenario occurred: wives refused to testify against husbands and lived "underground," men went to prison or moved to Mexico, women lived alone in another town or state, wives divorced husbands and/or testified against them. Jesse N. Smith had five wives (above, Margaret not pictured) and 44 children (left). Joseph Fish noted that in 1885 about 60 men left the towns, and "of this number seven were sent to prison, five went to Utah, and 48 went to Mexico." (Both, Marion Smith.)

Ida Hunt married David K. Udall in 1882 as his second wife. Her sister, May Larson, wrote that Ida "did not take the name of Udall for a long, long time" and, in fact, left Arizona two years later to avoid testifying against her husband. She lived underground in Utah for three years, during which time her daughter, Pauline, was born. (Marion Smith.)

Lorenzo Hill Hatch was called to Arizona in 1876, but only two of his wives accompanied him. He worked tirelessly to solve Woodruff's water problems, securing aid not only from the LDS Church but also from the government. In 1901, he returned to Cache Valley, but many of his children remained in Arizona. This floral tribute for his funeral in 1910 included photographs of three wives. (Sarah May Miller.)

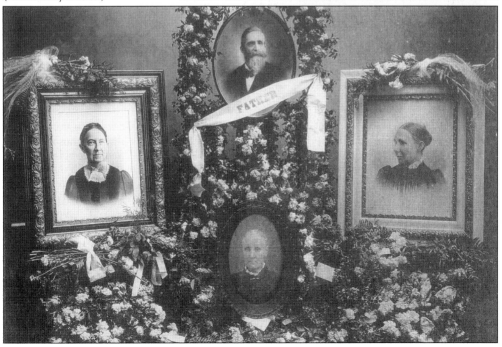

John Bushman was 32 years old when he brought his family to St. Joseph. Born in 1843 in Nauvoo, Illinois, he married twice and had 16 children. By 1938, his descendants were scattered from New York City and Washington, D.C., to Salt Lake City and St. George, Utah. They kept in touch with a newsletter, *The JB Roundup*, and scheduled a reunion for August 28 and 29, 1938. Florence B. Zobell wrote, "When it's melon time in Joe City, / We'll be coming back to you." She

described her grandfather's contribution: "Grandpa helped to make [northern Arizona] blossom, / Toiled and helped in every way. / Checked the dams and raised the harvests, / So that we might see This Day." The Holbrook Photo Studio (and proprietor Neal DeWitt) produced this image of the occasion. (AHS/Tucson No. 6942.)

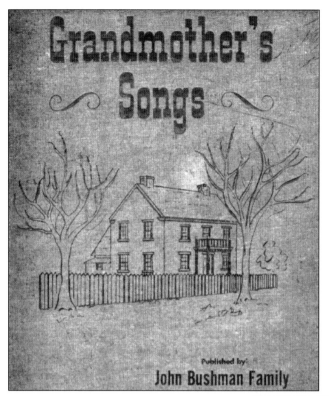

Grandmother's Songs

Published by:
John Bushman Family

A charming tribute to pioneers is the Bushman family's publication of the favorite songs of their two grandmothers, Lois and Mary Ann. Many tunes are English and American folk songs, but the book also includes a love poem written by Lois to her husband, John; five songs used by missionaries to Native Americans; and this admonition: "Daughter, don't let mother do it; / Do not let her slave and toil, / While you sit a listless idler / Fearing your soft hands to soil." (Karen Bushman.)

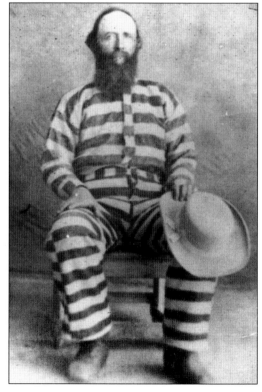

In December 1884, William J. Flake was sentenced to six months in prison at Yuma and received a $500 fine for practicing polygamy. He later enjoyed dressing in his prison clothes (note cowboy hat and boots). After Flake returned home and recuperated for a few weeks, Bishop John Hunt called and suggested they go for a walk. Hunt then said he needed to stop at the church, and there Flake found the townspeople waiting to welcome him back. When the manifesto renouncing polygamy was issued in 1890, not even Mormons understood its implications. Joseph Fish reported that in 1896, Jesse N. Smith "appeared to think that it was more of a political move." (Wanda Smith.)

A move to Mexico was one way to avoid prosecution; Jesse N. Smith Jr. left Snowflake in 1885 and died in Dublán in 1912. By 1900, the relative prosperity of Mormon towns in Chihuahua and Sonora attracted other settlers, including some practicing polygamy (Joseph Fish) and some not (William Hall). Hall's wife, Emma, and daughter Lillian (right) were photographed shortly before their departure from Snowflake in 1900. The Hall family lived in Colonia Dublán and then Morales, Sonora. Unfortunately Anglo exploitation of Mexico's Indians and natural resources led to a 1910 uprising of peasants, and, although Mormons tried to remain neutral, their ties to the United States led to an exodus in August 1912 (below, camped at Chuchiverache). The Hall family returned to Snowflake and greatly influenced the community. (Right, Ralph Lancaster; below, AHS/Tucson No. 58847.)

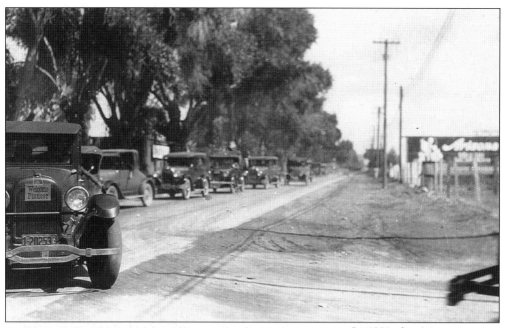

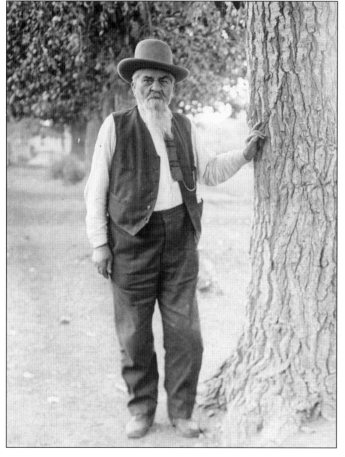

In 1921, the *Arizona Republican* sponsored the first statewide Pioneer Reunion for anyone who had lived in Arizona more than 35 years. On the second day, cars in Phoenix lined up to carry the pioneers down Central Avenue in a parade. Jim Pearce (left) was honored as having lived in Arizona longest (since a mission to the Navajos in 1858). Many pioneers told stories of killing Native Americans, but he reportedly said, "The only ones I killed, if any, were the ones who ran themselves to death chasing me." The inference was that there was little need, and no glory, in killing Native Americans. (Above, AHF MC-H-310:1; left, Shirley Cole.)

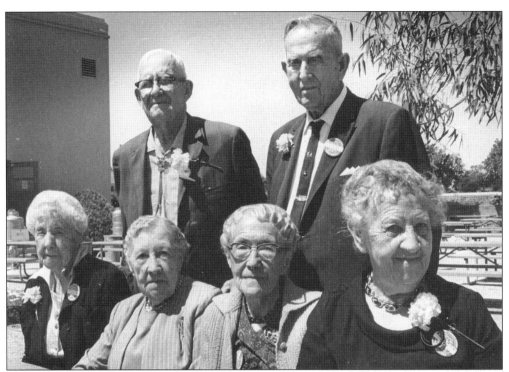

Northern Arizona pioneers continued to attend the reunions in Phoenix. In 1925, Julia West, Joe Sponseller, Hans and Loretta Hansen, J. A. Brewer, C. A. Gardner, Charlotte Webb, S. C. Rogers, and Annella Kartchner attended. In 1967, the living children of William J. Flake were photographed at the reunion (above): from left to right are (seated) Roberta Clayton (90), Emma Freeman (88), Pearl Ellsworth (84), and Wilmirth Willis (80); (standing) Joel W. Flake (82) and John T. Flake (86). Roberta Flake Clayton was one year old when she came to Arizona and lived to be 103; she became Snowflake's last living pioneer. Below, the remaining pioneers of Joseph City photographed on March 23, 1938, were, from left to right, Mary Richards, Emma Hansen, Sophia McLaws, and James E. Shelley. (Above, Ryder Ridgway collection, ASU Library, CP.RR.766; below, photograph by Max Hunt.)

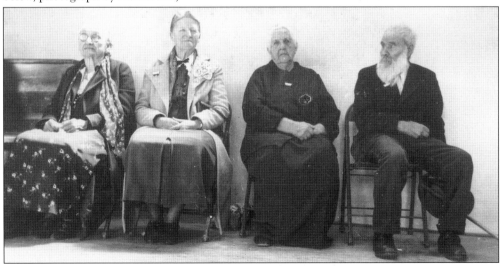

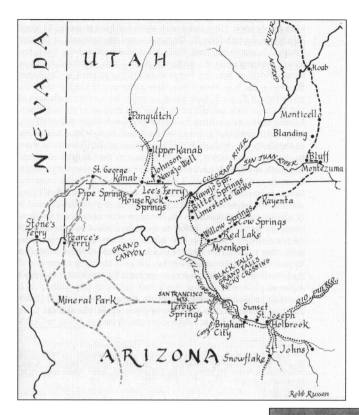

This map from Charles Peterson's *Take Up Your Mission* illustrates the normal route from northern Arizona to St. George through Lee's Ferry. Used often by young couples traveling to a temple, the route became known as the Honeymoon Trail. However, Bishop John Hunt's first trip (with John Bushman, Lycurgus Westover, and Henry Tanner) was through Pearce's Ferry. In addition, some of the Brimhall and Hatch families came through Bluff, Utah, and then western New Mexico.

Theodore Wilford Turley first came to Arizona with his father and spent February to August 1877 farming in Lehi (Mesa). When they returned to Utah, they re-outfitted and joined William J. Flake in trailing cattle over the mountains in ice and snow. In 1882, Turley and Mary Agnes Flake returned to St. George to be married; the trip took 21 days each way. (Wanda Smith.)

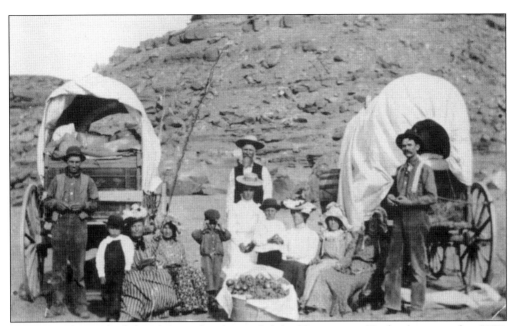

Preston Bushman (right) and Anna Smith traveled the Honeymoon Trail to be married in 1902. Adele Bushman and John Westover also went to be married; Joanna Westover was chaperone. Bill Cross said of a similar trip, "We had to dig for wood and climb for water," meaning sagebrush covered by drifting sands yielded nicely cured firewood and, when they spotted a green spot on the hillside, a little digging gave enough water to dip with a cup. (Georganna Spurlock.)

Later, couples traveled together on the train. On June 10, 1915, Ben and Pearl Hunt, John and Clara Miller, Burton and Jesse Smith (right), and Maurice and Jennie Rabin were married in Salt Lake City. The Hunts, Millers, and Smiths honeymooned in San Francisco and often celebrated their common anniversary together. All four couples lived to commemorate their 50th wedding anniversary. (Marta Moore.)

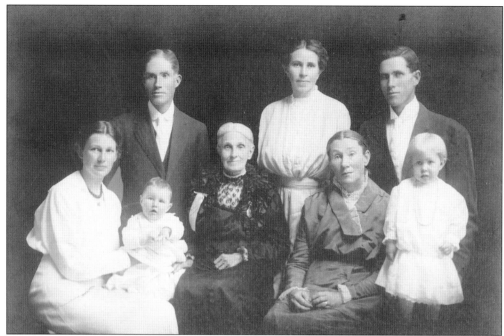

The long trip was also made to Salt Lake City to attend conferences and visit relatives who did not relocate to Arizona. In 1913, Clara Gleason Rogers and her sons Andrew (left) and Marion (with wives and daughters) visited their grandmother Aurelia Spencer Rogers (in the black dress). Aurelia is remembered for her work with children, including beginning the first Primary in 1878. (Leola Leavitt.)

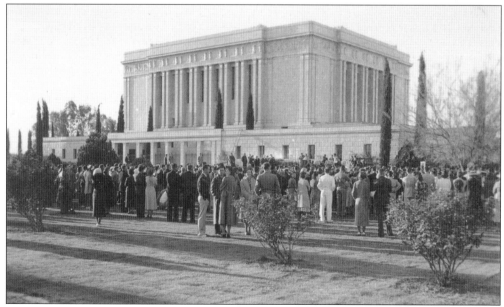

In 1927, the Arizona Temple in Mesa was dedicated, and couples no longer had to travel to St. George or Salt Lake City to be married. This image is of an Easter sunrise service, April 17, 1938, part of an M-Men and Gleaner regional conference that many young adults from northeastern Arizona attended. (Photograph by Max Hunt.)

Two

HOLDING ON

When William J. Flake bought land along Silver Creek, James Stinson cautioned that the water was not sufficient for more than a few farms, but Flake envisioned Mormon communities and opened the area for settlement. In reality, however, Stinson was right. Even with wells drilled decades later, there were not sufficient resources to support the natural growth from large Mormon families. Children (as young adults looking for work) became the area's biggest export—to Winslow and Holbrook, to metropolitan Phoenix, and to other states such as California, Utah, and Oregon.

But the settlers worked together to irrigate their fields, harvest their crops, brand their cattle, and build their towns. One of the distinguishing features of the area was the Snowflake Stake Academy, which was an LDS Church–sponsored high school. The *Snowflake Herald* reported in 1913 that faculty members went to Woodruff and held a meeting "at which many encouraging and instructive remarks were made in the interest of education. . . . The good results that accur [sic] from attending . . . was forcible and clearly presented to the people."

Politics also changed. Joseph Fish reported that in 1890, Pres. Wilford Woodruff of the Mormon church "thought that it would be better for our people to divide more on political lines, that is to be Republicans and Democrats." Not all agreed with the advice, but Fish reported, "I thought that the move that we made to split a little on politics was the best." The 1932 Official Register of Electors shows many Mormon homes with divided affiliation—the wife a Democrat and the husband a Republican, or vice versa. The Republicans, hoping to help their ticket in 1938, wrote a song (to the tune "Waiting for the Reapers" noted Rebecca Rogers in her journal) with a chorus about the candidates for supervisor; however, only John L. Willis won his seat.

> Then of course there's Supervisors
> For districts one and two and three,
> Newman, Greaves, and John L. Willis
> Can't be beat we all agree.
> Ye Republicans who are sleeping,
> Do not think that you can shirk.
> Now's no time for indecision,
> Rouse at once and go to work.

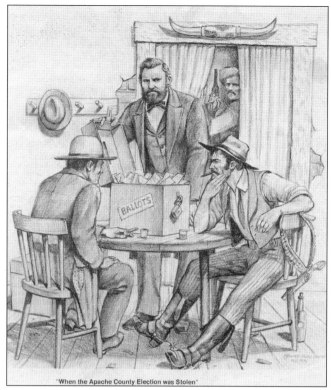

"When the Apache County Election was Stolen"

Early prejudice against Mormons centered on polygamy but played out in the political arena. Joseph Fish wrote, "Elections were of little use in Apache County . . . for the Board counted in whoever they pleased regardless of the number of votes." In 1880, Jesse N. Smith and John Hunt went to Springerville to help count votes. Smith's son was later told about the gunman behind the curtain whose job was to make certain Mormons were left out of office. (Drawing by Edward Silas Smith.)

Jesse N. Smith served on the 19th Territorial Legislature (1897). Some of the other legislators have included Q. R. Gardner (1900s), John L. Westover (1940s), and Eva Decker (left, 1949). Franklin J. "Jake" Flake (right) has served in either the Arizona House or Senate since 1996 and has been Speaker of the House and president pro-tem of the Senate. (Left, ASLAPR No. 98-0143; right, Jake Flake.)

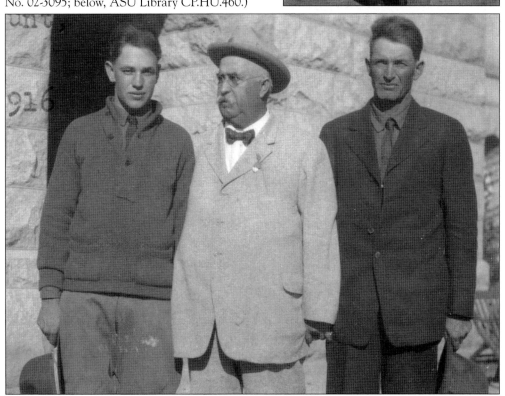

Gov. George W. P. Hunt was a populist Democrat. Influenced by his family's poverty after the Civil War, he supported free textbooks for schools. He loved to travel around Arizona and be photographed with his constituents. Likewise, he was loved by many Mormons, including James Pearce, at whose home Hunt would stay when he came to Taylor. At right, Hunt is photographed with Burton R. Smith (left) in Snowflake; below, Hunt is photographed with father and son, James H. (right) and Jesse Frost, probably at the state fair. Both photographs are from 1916. (Right, ASLAPR No. 02-3095; below, ASU Library CP.HU.460.)

LeRoy Palmer's years of public service included serving as Arizona state senator from 1971 to 1972 and as Navajo County supervisor from 1973 to 1976 (above). Palmer helped Taylor finance and build an airport, pushed legislation for Shoens Dam to control flooding and provide water for irrigation, and supported economic development (such as a shopping center) for Taylor. (Arvin Palmer.)

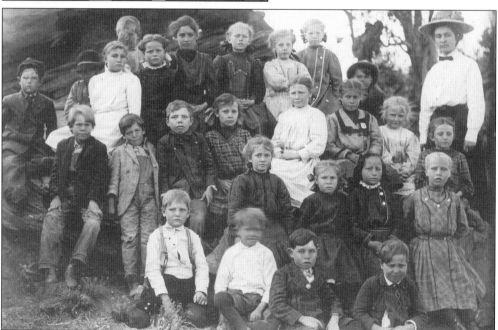

Children were valued in the Mormon communities. The first schoolhouse that Andrew Brimhall remembered in Taylor was built of logs and had a bell he liked to hear ring. The building was a meetinghouse, schoolhouse, amusement hall, dance hall, and theater. These *c.* 1910 Taylor schoolchildren include Leo McCleve (first row, second from right). (Shirley Cole.)

Leading the parade in 1891 at a celebration for 15 years of settlement was a wagon packed with children and the sign "1876 [sic]–1891, Snowflake's best crop in 15 years." Sarah (Sadie) and Walter Smith (pictured here c. 1896), children of John Walter Smith and Lois Bushman, were part of the next crop. (Smith Memorial Home.)

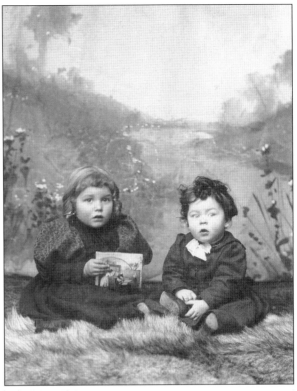

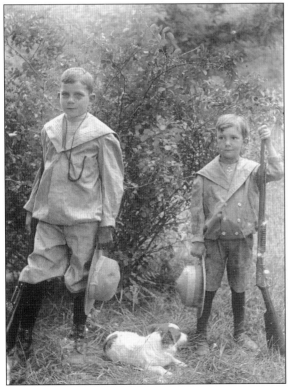

"A boy, his gun, and his dog" could be the label of this photograph of Frank Richards (left) and Chet Hunt. Born in 1905, Hunt contracted flu at age 16 and died of complications. Two days before his death, May Hunt Larson wrote in her journal, "Only three ladies came to [Sunday] prayer meeting as so many are sick with the flu."

To provide herself with dolls, Louise Larson Comish improvised—a corn doll with silk hair, a yellow crook-necked squash dressed in flour sack muslin, or white jimson weed flowers stacked together. These girls, however, pose with their china-headed dolls and doll buggies around 1910; from left to right are Charlotte Ballard, Marie Smith, Josephine Smith, unidentified, Thora Rogers, Cora Rogers, and Myrtle Smith. (Leola Leavett.)

As Lucy Turley Bates wrote, "Christmas was a big day. We didn't get many gifts but always something." A good Christmas in 1922 for the children of Asahel and Pauline Smith (twins Marion and Maria with their brother Phil, center) included a Pioneer Coaster wagon. (Marion Smith.)

Viola Pearce, 16-year-old daughter of Jesse Pearce (of horse and foot race fame) and Pearl Standifird, left Taylor and traveled to Flagstaff for a beauty contest around 1925. The next year, she married Grover ("Bill") Willis from Snowflake, and they made their home in Flagstaff. (Roma Lee Hiatt.)

Children in Woodruff climbed the butte, swam at the old dam, and hoed weeds. Marvin Gardner is photographed here with the family dog around 1947. He is the son of John and Kathelene Gardner and a great-grandson of two early Woodruff settlers, George Bryant Gardner and James Clark Owens Jr., the first bishop. He currently lives in Aztec, New Mexico. (Photograph by Max Hunt.)

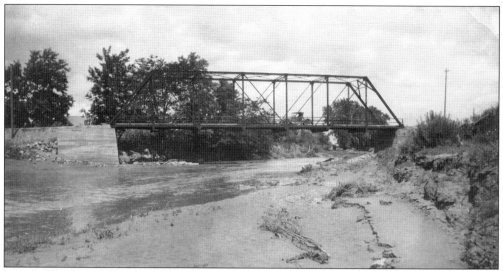

With Silver Creek (earlier Clear Creek) running through the town of Taylor, a bridge was imperative. This one-lane bridge, photographed in 1922, cost approximately $13,500 to complete and was predicted to stand for the next 50 years. Two previous bridges had been destroyed by floods. (NCHS.)

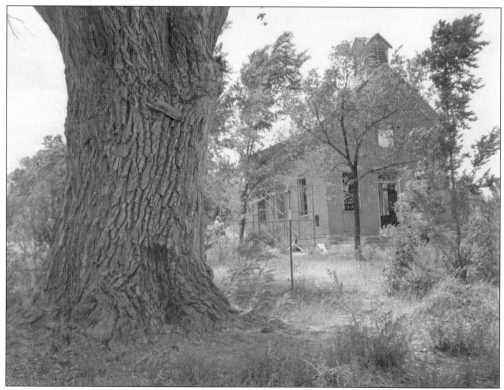

In 1904, a small, one-room schoolhouse was constructed in Shumway of locally made brick. The school was also used as a church, dance hall, and community center. Navajo County supervisors closed the school in 1947. This is the only brick, one-room schoolhouse still standing in Arizona. (Photograph by Garnette Franklin, NCHS.)

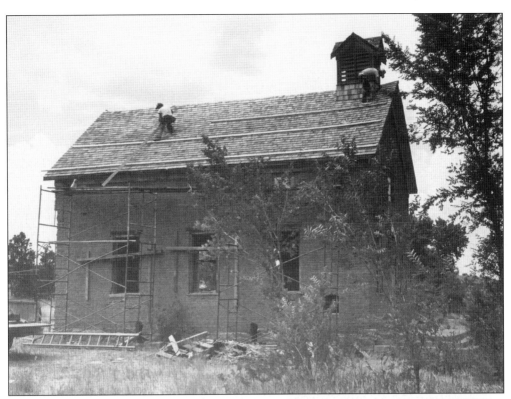

Left vacant, the building deteriorated until local schoolteacher Laura Saline began the campaign to save it in 1960; pioneer-era windows were installed from the Kirk Hatch house in Taylor. Today special arrangements can be made to view the interior, and names of early students can be seen carved into the brick. Former students (right) include, from left to right, Ella Rhoton Saddler, Harold Denham, Genevieve Rhoton Patton, and Ben Rhoton. In the 1985 book *Dust in Our Desks*, Lorenzo Rhoton told of teaching school nine miles away at Silver Creek when he was only 15 years old. He taught 26 children, all Hispanic, with nine older than he was. (Both, photographs by Garnette Franklin, NCHS.)

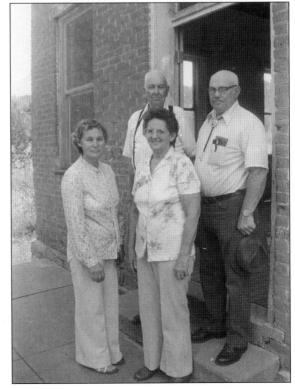

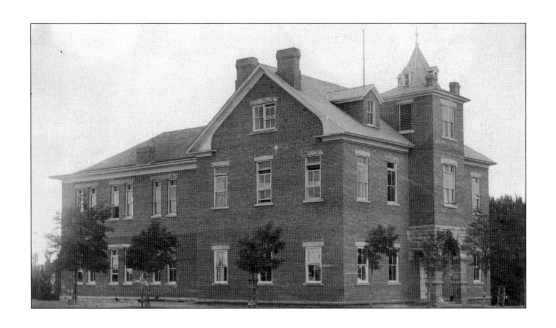

The original Snowflake Stake Academy (SSA, above) was a brick building erected in two stages. The front was built from 1898 to 1901, and then an addition containing an auditorium was added to the back from 1908 to 1910. Unfortunately the completed building was used for only three months; it was destroyed by fire on Thanksgiving Day. Construction began immediately on a new building (below), completed by 1913. The new building, made of red sandstone, was not as large as the original. (Above, Wanda Smith; below, Sarah May Miller.)

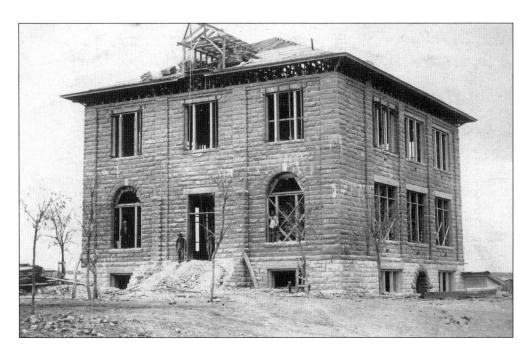

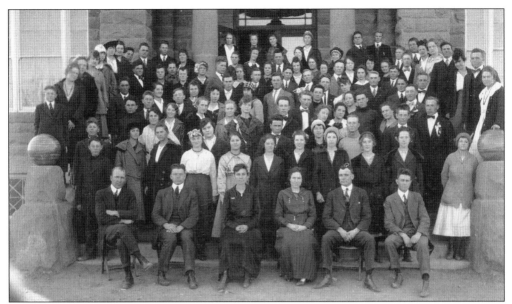

Students from Lakeside to Joseph City came to Snowflake for school and either lived with relatives, worked to pay for their board, or roomed together. In 1914, Laverne Richards, Myrtle Tanner, and Pearl and Delbert Hansen rented a two-room house from Tom Tanner that became known as "Uncle Tom's Cabin." A group photograph of the student body was usually taken each year in front of the academy building; above is the 1918 student body. (Sarah May Miller.)

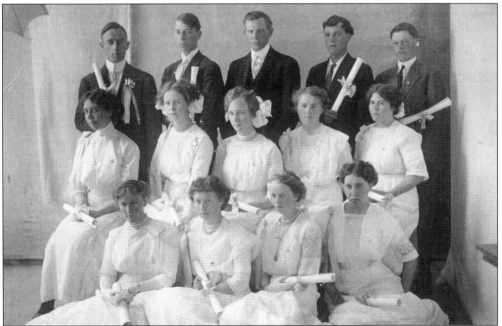

The graduating class of 1912 was, from left to right, (first row) Leah Smith, Lucretia Willis, Sophronia Smith, and Ada Peterson; (second row) Jennie Kartchner, Edna Greer, Louise Larson, Lydia Savage, and Nellie Flake; (third row) Charles Flake, Lafe Kartchner, Prof. Joseph Peterson, Earnest Shumway, and Silas Decker. The academy was converted into a public high school in 1924. (Arno Hall.)

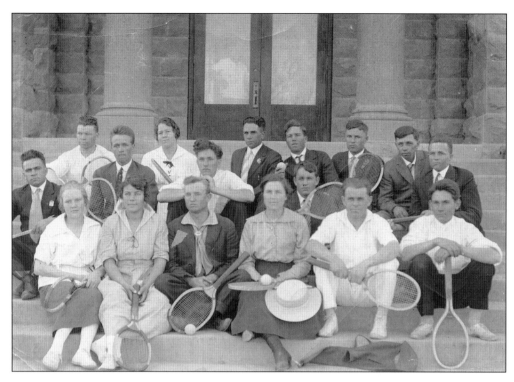

Virgil Smith, a forest ranger married to Blanche Hunt, was manager of a Pinedale baseball team playing Taylor around 1915. Pinedale was ahead 5-2. Margaret Shelley dashed out these words: "Dear to the heart of dear Virgil / Sweet are the men on his team / See them up to the home plate / At dearest Virgil's command. / They were hitting and running in tallies / But all at once it stopped. / We saw them walk to the plate / But dropped their bat at the umpire's command." With the song, Taylor rallied and won 9-6. A tennis team (above) and the women's gym class (below in 1917 with teacher Florence Bushman) provided variety in physical activities. (Both, Sarah May Miller.)

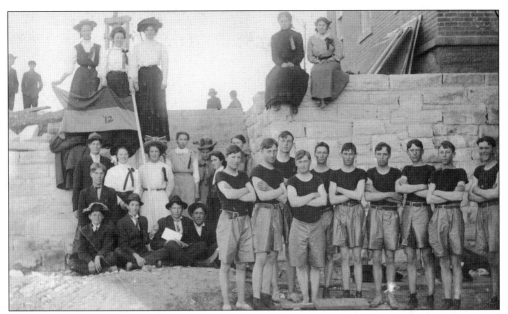

When the track team lined up by the academy on February 6, 1910, the girls and other classmates also posed for their photograph. The track team, from left to right, included Carl West, Loran Merrill, Al Shumway, Almon Owens, Charles Flake, Albert Hatch, Barr Turley, Lafe Kartchner, Ernest Shumway, and Ben Hunt. This was the last year of school for both Turley and Hunt at age 16. (Ruby Gibson.)

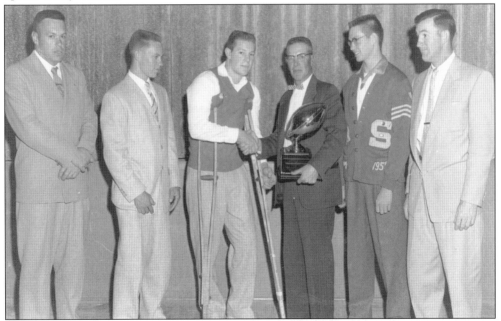

Winning football and basketball teams were always a cause for celebration at Snowflake Union High School. In 1959, the three cocaptains of the football team were photographed accepting the state championship trophy from fire chief Lorum Stratton; from left to right are assistant coach Glen Clark, Joe Spears, Danny Ramsey (on crutches), Stratton, Jerry Smith, and coach Tom Burr. (Lorum Stratton.)

Lucy Turley Bates wrote, "We looked forward to the 4th and 24th of July. The whole town took part. We started celebrating at daylight. Shot the cannon, fireworks, serenading, parade, program at the Church, big dinner at noon, sport and races in the afternoon, with prizes of candy and nuts. All who took part got some. July 4, 1906, I was voted in as 'Goddess of Liberty' (5¢ a vote). I had a white silk dress and gold crown and rode a decorated float pulled by four white horses. Andrew Rogers drove." At left are Lucy Turley and Tillman Willis as the king and queen of England. Below, on a Fourth of July (year unknown), the parade included a float with riders, from left to right, Nellie Flake, Vern Willis, Sarah Rogers, and Philemon Rogers. (Left, Wanda Smith; below, Roma Lee Hiatt.)

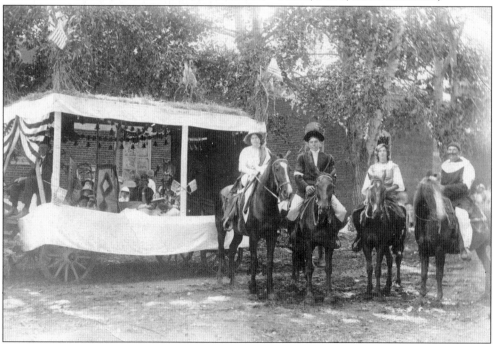

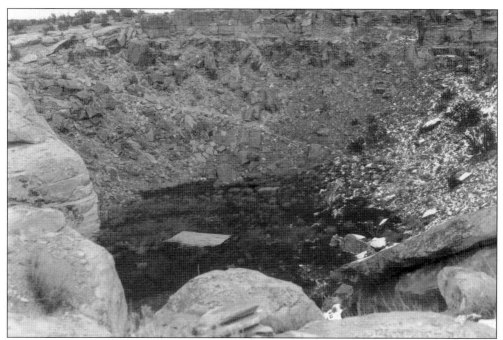

"Each year at graduation time," wrote Stan Turley, "a pageant was held at the 'Sinks,' [above] a place about ten miles [north]west of town where large sinkholes provided natural amphitheaters. . . . One year [1938] Dad let me provide about ten horses to be used in the pageant, and Earl Smith and I camped out for several days to care for them." Below, the 1938 pageant, "The Faerie Queen," featured Stan Turley (left), Norman Smith (knight), and Shirley Hoyt (fair maiden). Rex Gibson told of a 1935 pageant when the seniors wanted John Addison Hunt's "big white horse." Hunt was adamant that Gibson (a junior) "rode the horse or the horse didn't go." Gibson said, "There was a very disgruntled bunch of lordly seniors with a lowly junior riding with them." (Above, Cleone Solomon; below, Louise Levine.)

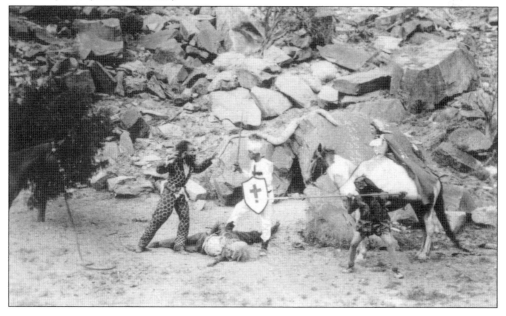

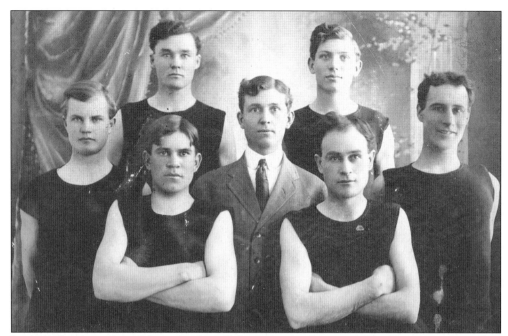

Jesse M. Smith graduated from the Snowflake Stake Academy in 1908, the only boy in a class of 10. He next attended Northern Arizona Normal School at Flagstaff for two and a half years. This image of the Flagstaff basketball team in 1911 includes Prof. John N. Adams (center) and (clockwise from left) John Gibbons, George Haynes, Maurice Blome, Junius Gibbons, Joseph Brinkerhoff, and Jesse M. Smith. (Cline Library AHS.0121.00001.)

The academy faculty in 1914 included, from left to right, Andrew Brimhall, Rufus Crandell, Joseph Peterson, Pearl Hansen, Hyrum Smith, and Jesse M. Smith. While in Flagstaff, Jesse M. joined the National Guard of Arizona on December 6, 1910. When he returned to Snowflake, he immediately began touting the benefits of an organized militia. On March 21, 1913, twenty men enlisted (including Brimhall and Crandell), and Company F was formed with Jesse M. as captain.

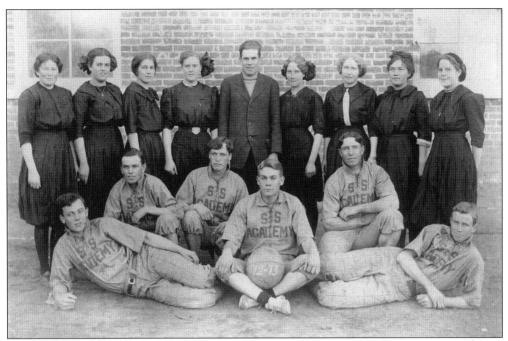

The oldest member of the militia was Z. N. Decker, who listed "one year military training Provo Academy [c. 1892]" for prior service. Jesse M. Smith also organized a military training class at the SSA, and four of these six basketball team members joined the class and the guard. Homer Willis even attended summer camp before joining and then added a few years to his age (as did Smith in Flagstaff) so he could enlist when only 16. (Louise Levine.)

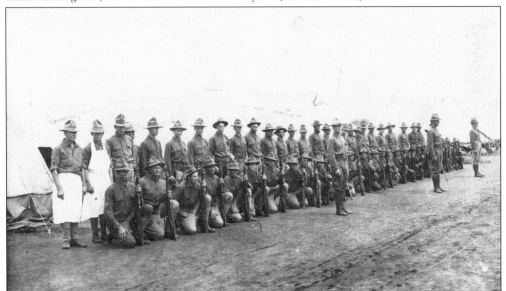

A total of 54 men became part of Company F in its brief three-year history. They attended encampments at Prescott in 1913 (shown above with Mesa's Company D under the command of Joseph E. Noble) and at Camp Huachuca in 1914. Most men in Company F changed to reserve status when Jesse M. Smith left on a mission, but 15 guardsmen served on the Arizona-Mexico border in 1916. (Wanda Smith.)

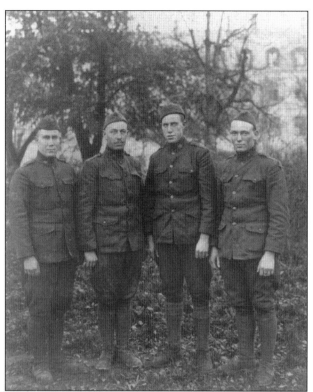

In 1917, northern Arizona men were drafted to fight in the Great War. Only a few young men (such as Lafayette Kartchner and Jesse Frost) were still active in the National Guard, and they left first. However, most single men were drafted. At left, from left to right, Alvirus "Bige" Rogers, unidentified, LeRoy Rogers, and unidentified were photographed in Europe; below, Charles Turley (left) and Martin D. Bushman are ready to leave from the train depot at Holbrook. (Both, Leola Leavett.)

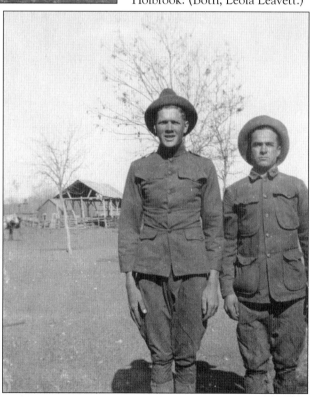

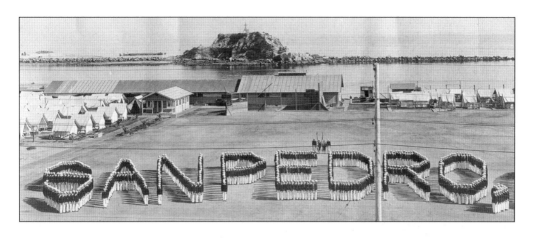

"In a 'news' reel . . . last Saturday night," the May 13, 1921, *Snowflake Herald* noted, "a scene was given of the navy boys' parade in Valparaiso, Chile. The naval fleet on the Pacific coast made a trip to South America a few months ago and sent out invitations to all 'gobs' who were with them during the world war to 'come along—let's go.' Delbert Hanson [*sic*] of St. Joseph was one of the number to accept, and happened to be in Snowflake and at the movie . . . and saw his outfit in the parade, although he didn't appear in the picture." The men first traveled to San Pedro, California (above), then sailed to Panama and Chile. As the ship crossed the equator, King Neptune rose from the sea and initiated all crossing for the first time (below). (Both, Sarah May Miller.)

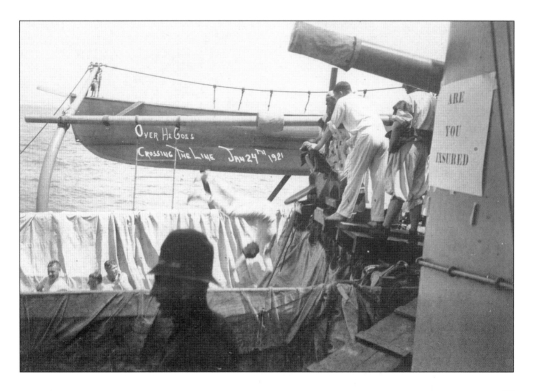

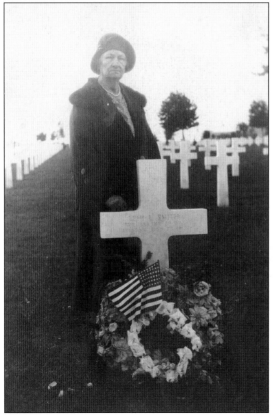

In 1930, Emma Larson Smith (above, left) participated in the Gold Star Mothers Pilgrimage to France. During and after World War I, great care was taken to identify the dead when they were buried. If the families requested the body be returned home, it was, but many of the 53,000 casualties were interred in France. Lehi Smith was buried at Meuse-Argonne. The federal government provided every comfort for 6,693 women to visit their loved ones' graves. A guide gave each woman flowers or a wreath to leave at the grave and took a photograph so she could remember her visit (left). One woman wrote, "Now that I have seen my dear son's resting place, and know that it will for ever be kept beautiful, I am more contented." (Both, Smith Memorial Home.)

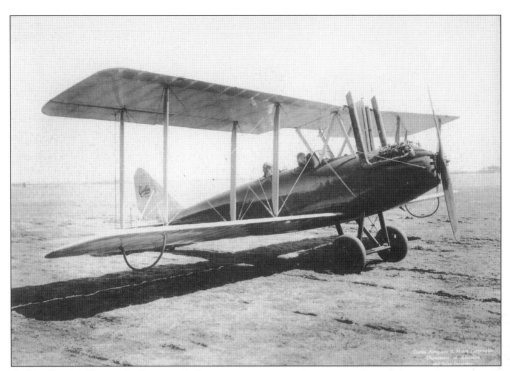

A 12-cylinder Curtiss biplane circled Snowflake in January 1921. Everyone came to see it. The pilot, Walter Ainslie, was from Glenwood Springs, Colorado, and had received his initial flight training during World War I. He was willing to give 10-minute rides for only $10; the Oriole could carry two passengers in front of the pilot. William J. Flake, 85 years old, was on the second flight and, according to the newspaper, "was just as game and plucky as any of the younger generation." Other adventurous souls were Francis McLaws Jr. (age 19), James DeWitt (19), A. G. McCloskey (40), Don C. Smith (34), James Hall (36), Walter Shelley (25), and Hyrum Broadbent (46, right). Flake said he had used oxen, horses, and automobiles, so he "might as well fly over and look down on the place." (Above, Glenn H. Curtiss Museum, Hammondsport, New York; right, Jess Broadbent.)

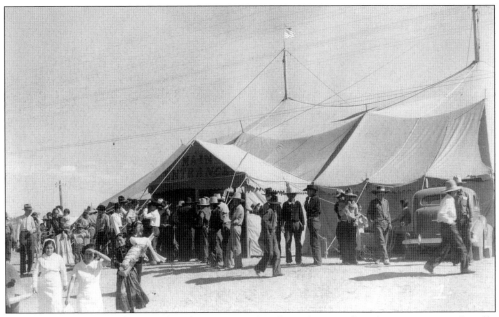

Circuit Chautauqua, the traveling brown tent that brought outside culture to geographically isolated farming and ranching communities, also came to Snowflake. In April 1921, the *Snowflake Herald* advertised, "If you love music, be there; if you like solid talks, hear them; if you are fond of dramatic entertainment, you will find it at the Chautauqua." This photograph was taken at Ganado, Arizona, in 1931. (ASLAPR No. 93-9913.)

Although this program is from Cape Girardeau, Missouri, Snowflake's Chautauqua was part of the Sunflower Circuit. In 1921, the program included music and dance from Swiss yodelers and the Maids O' Dundee in plaids and kilts, lectures by W. H. Nation, a magic show, and the Vernon Grimes Dramatic Duo. Individual afternoon performances were 55¢, evenings 85¢, and season tickets $3.

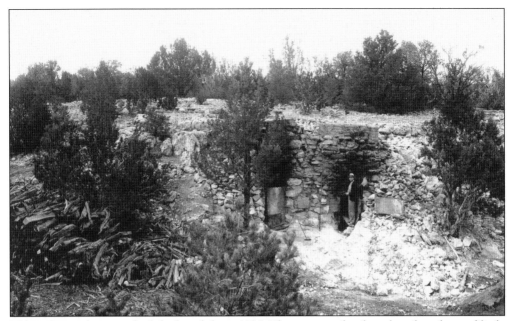

Milton Snow photographed the lime kiln in 1936. The process of making lime has changed little over several centuries; lime kilns usually required a day to load, three to five days to fire, two days to cool, and a day to unload. When heated, limestone decomposes into pure lime. As a boy, John Addison Hunt "helped to smash the lime and run it off into thick pits that made the mortar." It was also used for whitewash, removing hair from hides, and cess pits. (AHF DTO-119.)

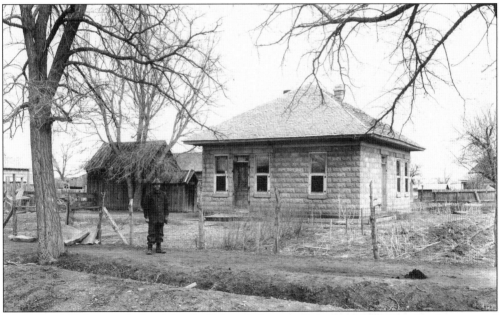

Ab (Albert) Flake was deaf and dumb. Although he attended school in Utah, when he returned home and no one else could understand sign language, he became an expert in pantomime. He is probably the man standing in front of his house shown here in 1936. The "bricks" for houses like these were made by filling molds (purchased at Sears and Roebuck) with concrete. (Photograph by Milton Snow, AHF DTO-99.)

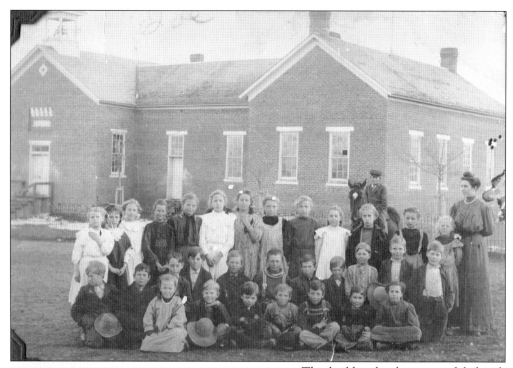

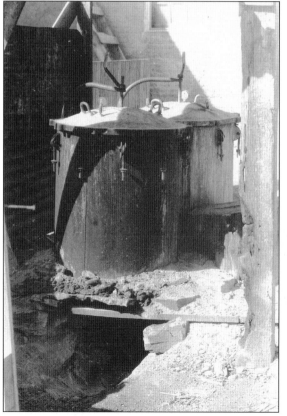

This building has been remodeled and is today the Snowflake City Hall. It was originally a school for elementary students (above in 1908 with teacher Leonora Smith Rogers and Ike Rogers on the horse) and has also housed the city library. However, in 1936, when Milton Snow photographed the town, it was a cannery. The two large pressure cookers (left) were photographed outside the building. A gasoline-burning pressure cooker was purchased in 1925 and could process 75 cans per hour. The building was also used as a mattress factory during the late 1930s; Beulah Stratton remembers going with her parents, Barr and Grace Turley, on assignment to work on the mattresses. (Above, Karen LaDuke; left, AHF DOT-106.)

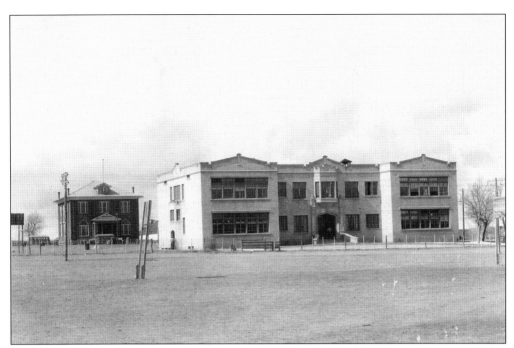

In 1919, a new school was finished in Snowflake (above, foreground) for grades one to eight. High school classes were held in the academy building (above, background). About 1918, Annis Jackson came to the academy from Pinedale as a boarding student. She remembered the installation of electric lights and being the only girl in geometry. After graduation and college, she returned to Snowflake and taught second grade for many years. In 1945, she married John T. Flake and lived on his farm between Snowflake and Taylor. David Butler (right), standing on the steps of the high school, was another beloved teacher. (Above, photograph by Milton Snow, AHF DOT-115; right, Renee Hughes.)

A group of Taylor young adults includes, from left to right, (first row) Effie Lewis, Laura Willis, Dice Brimhall, Logan Brimhall, and Charles Hatch; (second row) Dora Palmer, May Hatch, Clara Perkins, Mary Hatch, and Rex Shumway. At age 14, Logan began spending his summers at the Turkey Roost Ranch south of Pinedale. "As a consequence," he said, "my soul was deeply stirred by the restless silence of the forest." (Shirley Cole.)

Sports were always part of the high school curriculum. Stan Turley was a senior in 1938 and participated in a track-and-field meet. However, football was his forte; he made the Third All-State team and was, he wrote, "chosen to play in an Arizona All-Stars' New Year Day 1938 game in Phoenix against a Chicago team." Unfortunately Chicago won 9-6. (Photograph by Max Hunt.)

The church became the center of activity in each community. Snowflake began a building in 1883 of brick and lime locally burned; this was used for stake functions until 1938. Joseph City and Taylor each began buildings around 1904; Holbrook began around 1915. All were multipurpose buildings, although some church leaders thought dancing was inappropriate inside the church. This photograph is of the church in Taylor. (Shirley Cole.)

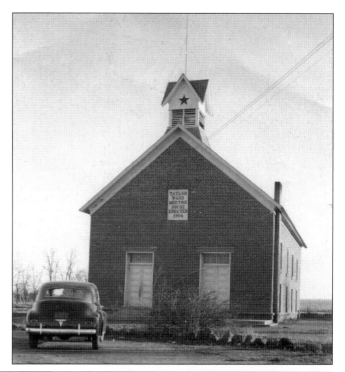

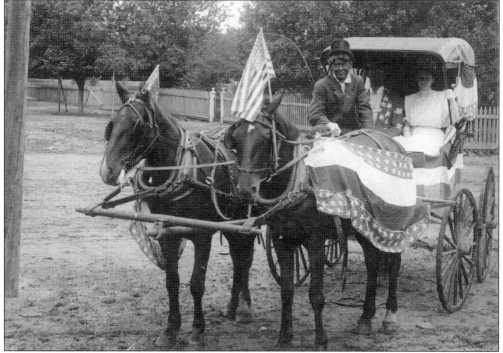

Next to the church in Joseph City was an empty square used for picnics and community gatherings. John Turley and his wife, Electra Westover, are photographed in the square and have decorated their team and buggy for a patriotic celebration. Complete with unidentified driver, they pose as a Southern gentleman and his lady. (Claudia Sullivan.)

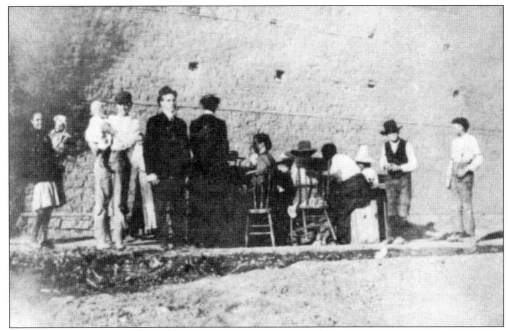

Mormon women have always quilted, mostly from necessity. This early photograph is of women working on a quilt in the sun outside the ACMI store at Woodruff. The "great Relief Society work," as May Hunt Larson called it, also included lobbying for woman suffrage and wheat storage. (Morjorie Lupher.)

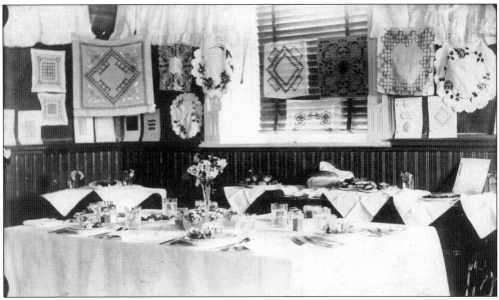

At the academy, girls learned both fancywork and the practical skills associated with running a home. In March 1914, the *Snowflake Herald* reported, "Domestic Science C girls are having their examinations every Thursday. Certain members prepare and serve a banquet, while others act as the entertainers of invited guests." This photograph shows a display at the 1907–1908 fair from the students of Pearl Potter. (Karen LaDuke.)

Quilting experienced a national revival in the 1930s with patterns published in many women's magazines. In 1933, May Larson recorded that she and her sister Belle Flake spent the day making a quilt "with a heavy outing flannel and a wool bat which made a very serviceable quilt." They also participated with 70 other women in making this friendship quilt, given to Relief Society president Moneta Fillerup. Moneta's granddaughter, Wanda Smith (at right with Beulah Stratton [left]), and siblings donated it to the Freeman home for display. The design is a variation of the Colonial Lady; each woman's name was included on her contributed square as an extension of the ribbon on the bonnet. The women who created this quilt ranged in age from 84 (Margaret Baird) to 20 (LaRue Bigler). (Below, David Ellis.)

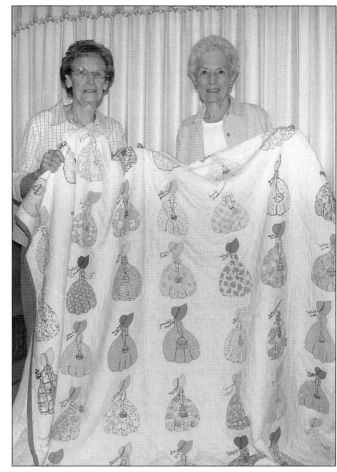

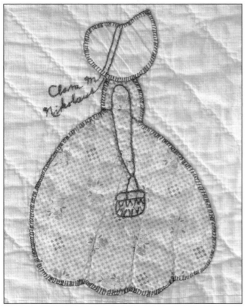

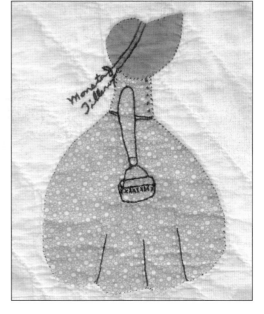

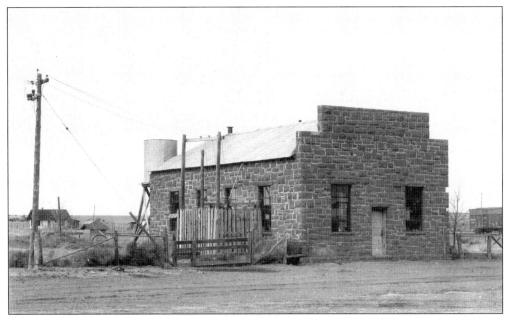

This building was erected in 1928 to house the one-cylinder Fairbanks-Morse diesel engine and generator used to supply power to a well pump. Water was pumped into the storage tank and then gravity flow water was available for Snowflake homes. The next year, a swimming pool was added, which was filled on Monday and drained on Saturday. Very few braved the cold water on Monday. (AFH DTO-103.)

Originally this building housed a bank and C. R. Fillerup's county extension office. However, when Milton Snow photographed it in 1936, the building was vacant. That changed with a Salt Lake City General Relief Society charge in 1937 to improve maternity care. By 1939, Leonora S. Rogers had everything in place for the Snowflake Maternity Hospital to open. Over 500 babies were delivered here from 1939 to 1960. (AHF DTO-104.)

As Kathryn Walling stated, "Doc Webb is an enigma—even his family doesn't know a lot about him." He said he lost his arm in a mining accident; he lost his leg to diabetes. He came to Snowflake in the 1920s and married Marguerite Willis, who was 25 years his junior. Originally trained as a veterinarian, he became a chiropractor whom many people loved. (Roma Lee Hiatt.)

Although the 1943 *Ladies' Home Journal* article was really about Deane and Harriet Curry, who worked for Bill Bourdon, the caption of this photograph of Neal Heywood with the Curry children noted that he had "delivered them all." The Currys moved into Snowflake each winter for school and "also think Mormon Sunday school for their youngsters is a good idea." Dr. Heywood is credited with having delivered over 2,000 babies. (AHS/Tucson No. 40809.)

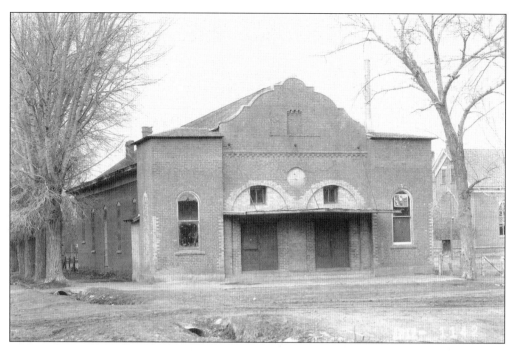

Dancing was always a part of Mormon culture. Lucy Flake Bates wrote of a 24th celebration with "a children's dance in the afternoon and a big dance at Flake Hall at night." By 1909, the Social Hall (above) had been completed on church property. One *c.* 1914, two-week Christmas season, there were 10 dances between Snowflake and Taylor. May Hunt Larson noted in 1913 a "Military Ball. Boys dressed in uniform." Other dances had creative themes such as the "Rabbit and Prairie Dog Dance," a contest between married and single men who saved the ears and tails of animals killed (thought of then as vermin) as tickets to the dance. The photograph below is of Joseph City friends ready for a dance. (Above, AFH DTO-113; below, Sarah May Miller.)

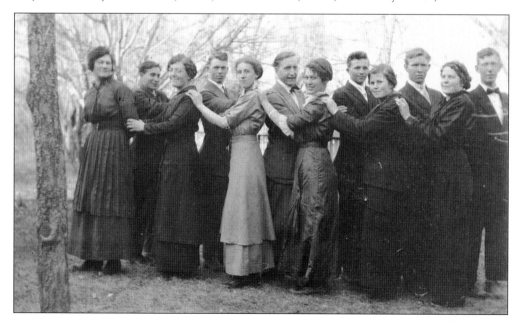

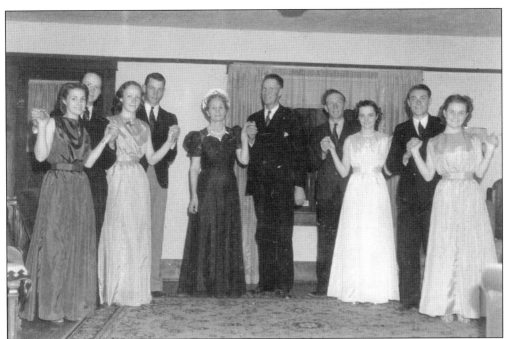

With gold and green the official colors for the Mutual Improvement Association, in 1922, a Gold and Green Ball was held in Utah; this dance soon became a part of each Mormon community. In 1938, the queen was Sarah Smith, escorted by Marion Rogers (center). Other couples included, from left to right, Marlene Larson and Orr Owens, Marsha Hunt and Marion Smith, Lewdell and Mettie (Reidhead) Hunt, and Melvin DeWitt and Genevieve Smith. (Marion Smith.)

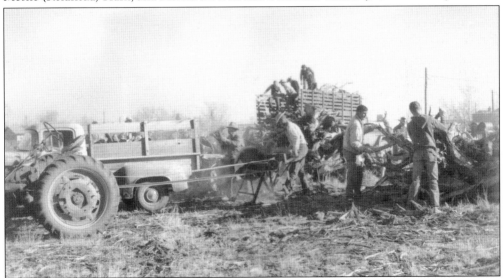

Snowflake townspeople, concerned about heating widows' homes in the winter, began a Thanksgiving Wood Dance. Men and boys gathered at 8:00 a.m. Thanksgiving morning for this service project. This November 23, 1961, photograph shows juniper wood brought in by a two-and-a-half-ton truck, cut to length by a tractor-driven saw, and loaded into a pickup for delivery. Ern Ramsay (left), Hunt Ramsay (center), and Max Evans are in the foreground. (Photograph by Albert Levine.)

Charles Ballard, his wife, Julia, and daughter Phyllis are shelling corn, presumably to be dried and then ground into meal. However, Ballard is remembered for a wheelbarrow of wood taken to Matilda Farley when she did not have enough wood to last the night (c. 1893); Theodore Farley was on a mission. Subsequent acts of service became the basis of the Wood Dance. (Ida Webb collection, Taylor Museum.)

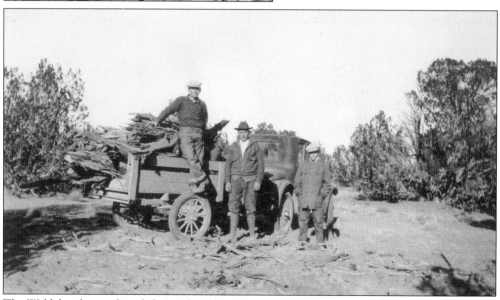

The Webb brothers—from left to right, Chet, Loran, and Leo—of Joseph City and Taylor hauled many loads of wood to heat their own homes and to sell. Max Hunt remembered some rancid biscuits when Clara Mosely accidentally used burro fat: "These burros ran wild south of Joseph City and when the men went out to haul wood, sometimes they would shoot a burro and hold a donkey barbecue and use the burro fat for their harnesses." (Ida Webb collection, Taylor Museum.)

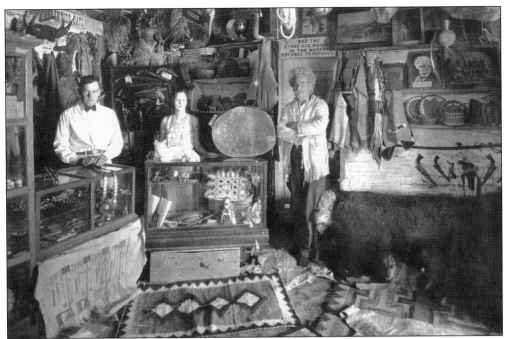

Frederick "San Diego" Rawson (right, with Dan and Martha Richards) was described by the *Holbrook Tribune-News* as "one of the most colorful, 'wild and wooly' old-timers in Arizona." Although born in New York and having lived in Michigan as a child, he came west as an adult and never looked back. He was a miner in Colorado, a dog showman in California, and "retired" to Joseph City as a writer with a "museum." In 1942, he offered the Red Cross "a fine pinto horse," for auction or sale, as his war contribution. He wrote, "I am not active enough to take a part in this war, but I want to do my bit. I have no money, even for stamps; I suppose you know roadside curio places are about off the map." (Both, Ruby Gibson.)

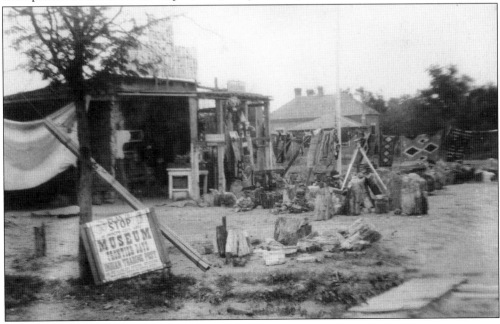

Edwin Decker and Sarah Rogers were married in 1923 and immediately enrolled at Flagstaff Normal School. Both then became teachers, and Edwin took odd jobs (including at the WPA near Springerville), but the Depression years were difficult. Their daughter, Eva Whitt, remembers salt-rising bread and "the special applesauce cake with walnuts, raisins and chopped orange gum drops—topped with boiled white frosting" for her father's birthday. (Ralph Lancaster.)

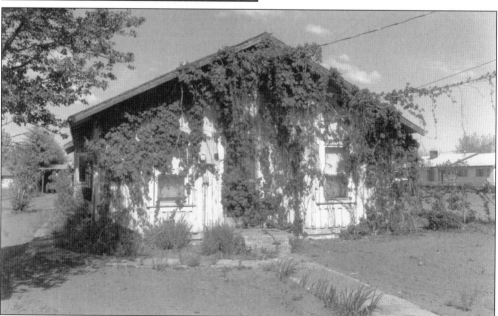

This board-and-batten home is owned today by Herb Decker and was built in the mid-1920s by Herb's father, Edwin. Sun-dried adobes were faced with vertical boards whose joints were covered by narrow strips of wood (batten). Originally only three rooms, another bedroom and a bathroom were added in the 1950s. William E. Ferguson, a photographer from Flagstaff, finds the home and vines picturesque and photographs it each time he visits Snowflake.

Three

FARMERS AND RANCHERS

For over 100 years, Snowflake, Taylor, Woodruff, and Joseph City residents have endured the relentless spring wind and engaged in every aspect of farming and ranching. Lucille Palmer wrote, "For his first corn crop Elijah [Murray Thomas] rode ten miles horseback for seed and planted five acres hill by hill, dropping exactly four kernels in each hill."

Few crops were raised without irrigation, which required constructing dams and ditches. William J. Flake and sons probably had the largest cattle herds. James Pearce brought in a large herd of sheep, and Jack Hatch told of shearing every year for 40 years. Taylor, Woodruff, and Joseph City supported successful dairies. James Hansen sold honey; others raised pigs and poultry (and produced eggs). A gristmill and a canning factory processed farm products. The Smith, Flake, Palmer, Willis, and Bushman stores marketed local produce. Charles R. Fillerup was the first county extension agent, and at the high school, the Future Farmers of America flourished with advisors such as Elwood Peterson supervising student projects.

In the 1940s and 1950s, cucumbers became an important cash crop. A contract with the Arnold Pickle Company of Phoenix meant farmers were paid according to the grade of cucumber: large No. 3s brought only 50¢ a hundredweight, but the very small, special grade paid $5. In 1944, a 14-year-old Dale Shumway cleared $800 on two acres. But cucumber production required labor-intensive weeding and picking. Sometimes Navajos were used as laborers, as Max Hunt told in his short story, *The Last Doll*:

> A childless Navajo Indian couple about 40 years of age waited in the house while I wrote out their final cucumber picking check. The woman noticed my teenage daughter's "last" doll and sat it on the couch beside her. She stroked its hair, smoothed its dress, and gazed wistfully at it from time to time.
>
> "Would you like to have it?" I asked.
>
> Without raising her head, she nodded yes.
>
> I considered a minute and said "okay." I never knew whether she wanted it for some little Navajo niece, or for herself.

Farming and ranching almost always involved every family member. Max Hunt photographed his daughter Catherine in 1947 with a Hereford cow. Dean Shumway taught her to milk a cow at age nine. By age 15, she was cutting the hay, and at age 18, she drove the truck to deliver hay to Winslow. The adage "You can take the boy out of the country, but you can't take the country out of the boy" applies to girls also.

Woodruff's farming activities were always dependent upon the construction of a dam on the Little Colorado River (14 total); Charles Peterson called it "The Famous Woodruff Dam." However, the canyon also had wild grapes. Q. R. and Mary Gardner are shown here with their children on a grape picking excursion. (Brenda Johnson.)

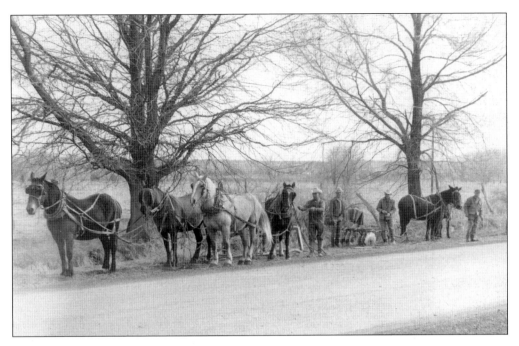

One late-winter or early-spring chore in a western farming community (using irrigation and before concrete ditches) was cleaning the ditches of weeds that would otherwise impede the flow of water. Here a four-horse team and a pair of mules are used in Taylor around 1958. The men above are, from left to right, Leo McCleve, Josh Allen, Ralph Reidhead, and Ern Ramsay. Early farming communities depended upon their workhorses. People in Snowflake purchased a Percheron stallion, Isadore, to upgrade the quality of their horses. In 1921, the *Snowflake Herald* advertised "Replace Scrub and Grade Sires with Good Purebreds: Join the 'Better Sires—Better Stock' Campaign." (Both, photographs by Max Hunt.)

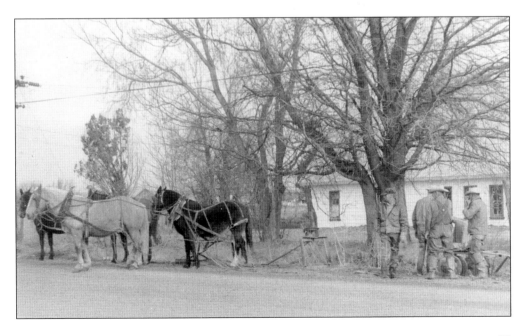

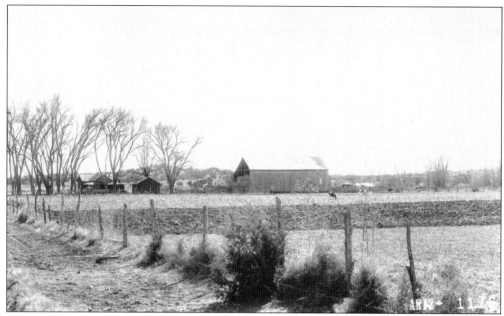

Farms and pastures (such as these between Snowflake and Taylor, photographed in 1936) depended upon water. Originally water came from nearby streams. Jesse N. Smith wrote that in 1896, church leaders requested representation at an irrigation congress to be held in Phoenix because "the Mormon people were considered the pioneers of irrigation." Smith, John Hunt, John H. Willis, and Joseph Richards attended. (Photograph by Milton Snow, AHF DTO-114.)

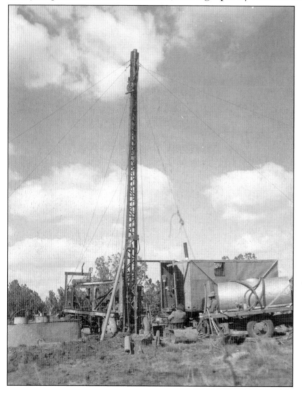

Wells drilled around Snowflake added farmland. In 1942, Earl White was drilling wells at Hunt and was willing to come to Snowflake if guaranteed three wells; Marshall Flake agreed to two and Lorenzo Decker one. Surface water was found at 25 feet, but a better water source was in the Coconino Sandstone at 250 feet. This was one of Flake's wells. (Photograph by Albert Levine.)

The Willis family lived on Back Street and included brothers John Henry, Amasa, Ira, Heber, Rhode, Angus, and Parley. James Jennings described them as gregarious and hardworking, with a sense of humor. They were also known for their parties and family gatherings. This late-1940s photograph of Willis family members includes the Carragher, Webb, Miller, Stratton, Cooper, Wasson, Gardner, Solberg, and Turley families. (Roma Lee Hiatt.)

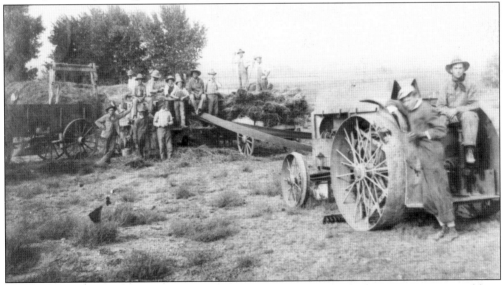

The Willis brothers had the first threshing machine along Silver Creek; it was powered by a team of 10 horses. In the late 1920s, this small steel-wheeled, gasoline-powered tractor was used in Woodruff. A power transfer pulley on the side operated the belt attached to the thresher. It appears that the wagon on the right has shocks of grain and that the wagon on the left is full of straw. (Morjorie Lupher.)

Snowflake always had 100-foot-wide streets. Tradition says they were built wide enough for six-horse, double-wagon freight outfits to turn around (as tracks show here in 1936). Note utility poles in the middle of the street, pronounced a menace to public safety as early as 1921. The committee of L. C. Owens, M. H. Flake, and Jesse M. Smith were apparently unsuccessful in relocating the poles. (Photograph by Milton Snow, AHF DTO-110.)

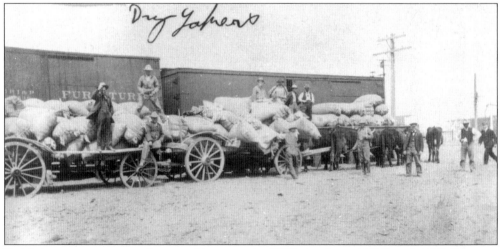

Freighting contracts generally rotated between the Willis brothers, ACMI, and A&B Schuster, who each had large corrals at Holbrook where freighters could camp. Almost everyone hauled freight sometimes, usually with six horses and two wagons; every necessity was carried—from barbed wire to cookies. The men here have been identified as "Dry Lakers" (men from Zeniff) and also Levi Heward from Woodruff; the cargo is certainly wool. (Morjorie Lupher.)

Horses provided transportation—everywhere. Osmer Flake wrote that his mother "used to say that if she asked [his father, William Jordan] to gather the eggs, he would saddle his horse." John Addison Hunt was still breaking horses when he was 70. This is Frank Gibson on a horse named Paint at Aripine or Heber. (Ruby Gibson.)

Victor Colbath (left) and John Palmer are photographed in front of the A. Z. Palmer home in Taylor. Colbath bought a horse from Johnny McCleve that learned to use its mouth to grab the rope on the well pulley and raise and lower the bucket over and over again. After farming in both Mesa and Mexico, John Palmer homesteaded Oklahoma Flat, which became Overgaard. Palmer was a left-handed roper, so his horses were generally useless for others. (Ida Webb collection, Taylor Museum.)

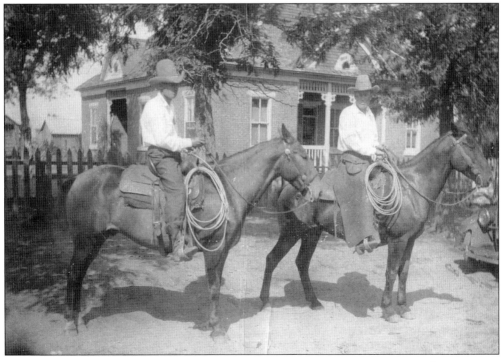

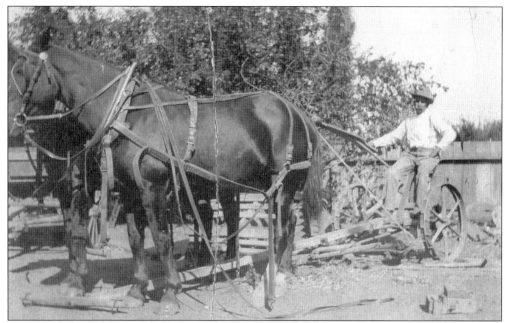

In the mid-1920s, construction began on Highway 66, and as Max Hunt remembered, "quite a few of the farmers in Snowflake who owned some good quality, big Percheron work horses" came to work. They had a camp near the Joseph City reservoir, and the Hunt children "would take down fresh milk in a bucket every night." John Freeman poses here with his team of horses in 1941. (Freeman Home.)

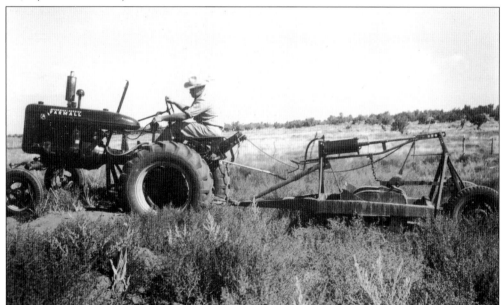

By the 1940s, modern scrapers had replaced the Fresno and slip scrapers formerly used in road construction. Al Levine is shown here using a small McCormick-Deering tractor and scraper to level land east of Snowflake. The Farmall A had the engine offset to the left and the seat and steering rod offset to the right, giving the driver a great view of the ground below the tractor. (Louise Levine.)

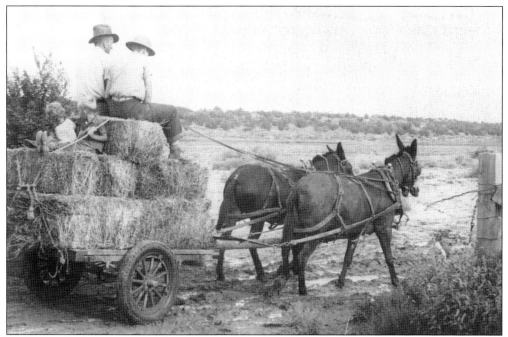

With newly drilled wells, additional farmland was available after World War II. Ben Hunt and sons purchased land at Hay Hollow and planted alfalfa; the hay was used at the Homestead Dairy near Joseph City. Rex (left) and Rolf Hunt use two mules, Kate and Jack, to bring in bales of hay (the children are Todd and Sue Hunt). (Photograph by Max Hunt.)

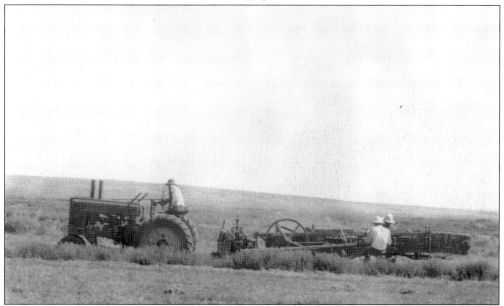

Baling hay in 1946 at Hay Hollow required three men, with two pushing wire through and twisting it closed. Often one of these was a Navajo named Notto. One day, the baler picked up a snake and smashed it into the bale, and the head was waving around on Notto's side. He got off the baler, began walking to town, and could not be persuaded to work more that day. (Photograph by Max Hunt.)

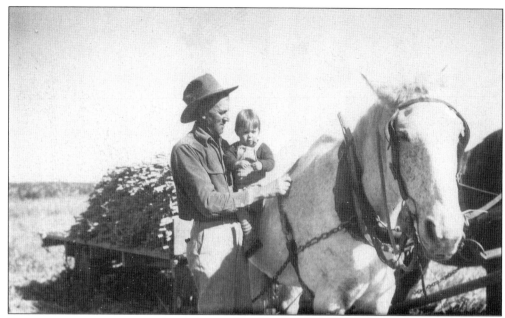

Sugar cane was grown to make molasses. Virgil Bushman wrote that he sold "quite a lot of molasses to some sheep men" in Winslow in 1922, and Lorenzo Rhoton remembered molasses taffy pulls. Asahel Smith (with granddaughter Emily Church) stands by a load of cane. Charles Peterson said that when his father, Joseph, died and the family needed to take their water turn, Smith simply came to the ditch bank to do the watering so Peterson could attend the funeral. (Marion Smith.)

Hopis and Navajos sometimes worked for farmers and ranchers in northern Arizona. These women have been picking cucumbers at Hay Hollow for sale to the Arnold Pickle Company around 1960. A sudden thunderstorm on a feeder wash of the Little Colorado River had made the water too deep to cross. (Photograph by Max Hunt.)

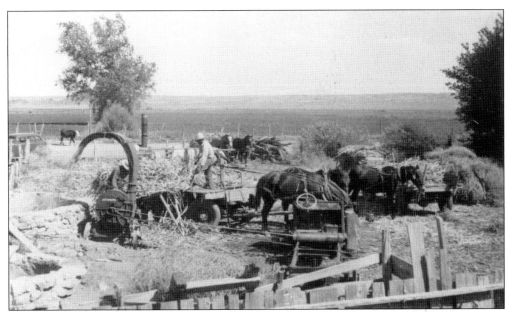

Corn was planted for silage. When the ears were mature, the entire stock was chopped and stored in silos, often made of concrete or stone, either above or below ground. The corn then fermented and could be used to feed cattle during the winter. When dairy cows were fed silage, they produced milk of good quality and taste. In Woodruff (above), Elmer Gardner uses a team of horses to bring in corn to be chopped; Hyrum Turley is at the cutter near two underground, stone-lined silos. A stripped-down automobile with long belt had been modified to power the cutter. Below, around 1960, Rex Hunt at Hay Hollow is chopping his corn, which would then be hauled to the silo. (Above, Morjorie Lupher; below, photograph by Max Hunt.)

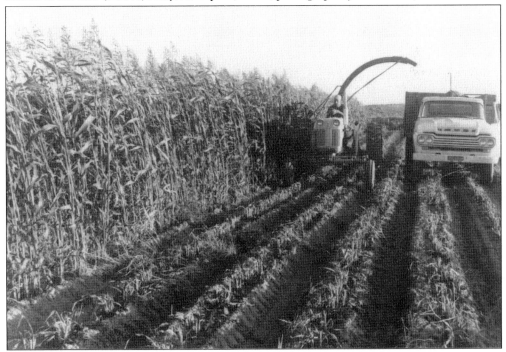

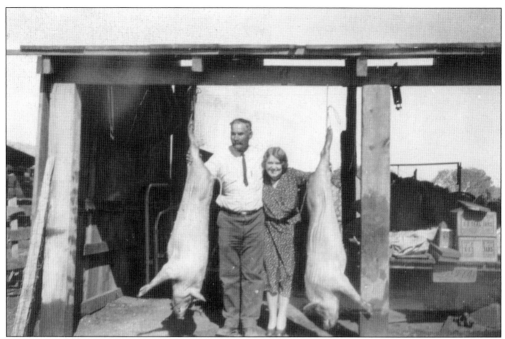

Charles and Moneta Fillerup fled Mexico with other Mormons in 1912 during the Mexican revolution. They lived in Tucson, then Cochise, and in 1915 came to Snowflake. For 20 years, Fillerup was the county extension agent for Navajo and Apache Counties. He traveled extensively, helping farmers and ranchers produce better crops and raise healthier livestock. He supervised displays of agricultural products at the county fair and attached a crate to the side of his car so he could haul calves or trees for his farmers. Above, C. R. Fillerup stands with his daughter-in-law Bessie between two butchered hogs; below, a group of men and boys in Pinedale gather so Fillerup can teach them how to prune trees. (Above, Wanda Smith; below, photograph by Charles Fillerup from Arvin Palmer.)

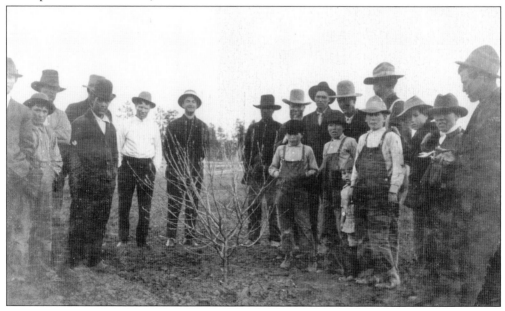

Snowflake had many expert small-vegetable crop farmers who supported their families by the sale of these vegetables. One was Ben Rencher, shown here with his entries for "Irrigated Field Crops" at the county fair in Holbrook in 1965. His wife, Minnie, said that when they sold corn, 13 ears always made a dozen. (NCHS.)

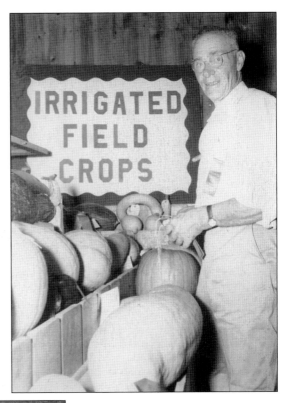

Another truck farmer was Martin D. Bushman (here in mid-1960s Snowflake). In 1917, the *Snowflake Herald* reported that he "returned from his watermelon patch at St. Joseph to attend the S.S.A. [Academy] for another term" and made "about $400 on melons," but he expected to "beat that record next year." In 1925, he traveled to Gallup with C. R. Fillerup to arrange a market for farm produce. (Photograph by Max Hunt.)

Mail contracts provided additional income; Fred Turley had a weekly run from Holbrook to Heber for eight years. His wife, Wilma, wrote, "When the going got too tough for Fred in the mail truck, I took the mail horseback [from Aripine] to Heber on Old Midnight. In the spring . . ., the roads were so soft that a car couldn't make it in the afternoons, so I had the great delight to ride the 13 miles to Heber and back." (Wanda Smith.)

Possibly the most beautiful farmlands are the fields along Silver Creek in Shumway, photographed by Milo S. James in 1950. An article in the September 1921 *Snowflake Herald* described Shumway as "one of the beautiful places of southern Navajo county" and concluded, "For an outing or a day's picnic, we suggest Shumway. The people are hospitable and sociable, and you'll enjoy the place." (AHF N-11.)

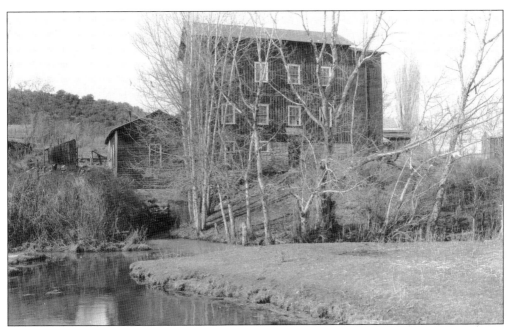

In the 1880s, Charles Shumway built a gristmill on the banks of Silver Creek; the exterior and interior were photographed by Milton Snow in 1936. All grain grown in northeastern Arizona was milled here until the 1950s, when Spencer Black bought the mill and began making flour and animal feeds in Snowflake. Black learned milling from his uncle, Ether Black, in Blanding, Utah. Electricity was also produced at the Shumway mill site in the 1920s with the operation supervised by Ed Muder. Germade, a hot breakfast cereal, is a specialty that many people return to Snowflake to purchase even today. (Above, AHF DTO-124; below, AHF NA-14.)

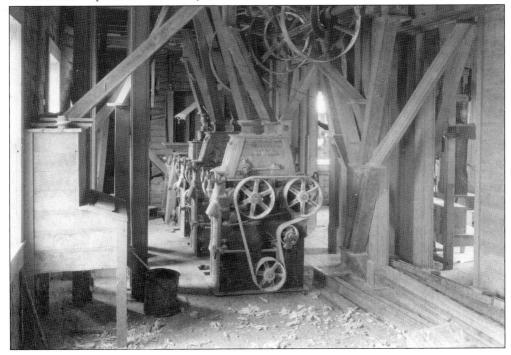

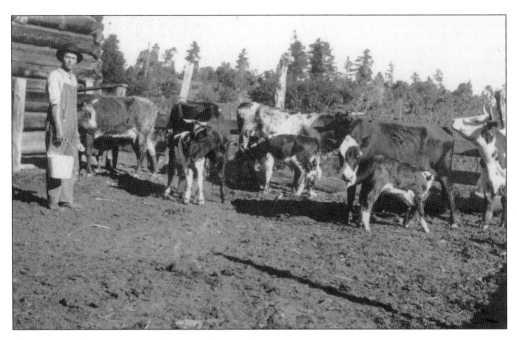

The first summer that Ben and Pearl Hunt were married (1915), they spent near Pinedale; Ben milked his cows, and Pearl later reminded people that she started housekeeping in a tent. Next Ben worked for the ACMI in Holbrook. His son, Max, said, "He got to selling milk to people that he knew in Holbrook. It was just personal friends to start. . . . Eventually this led to giving up the job at the store and going into the dairy business full time." In 1939, Pearl wrote to Max, "You asked if we had all the milk we could sell. No, we haven't. Dad is up to Woodruff now trying to locate a cow. We are selling about 140 qts., 12 pints, & 110 little bottles per day now and we are still short."

As early as 1878, Mormon settlers from Sunset were pasturing their cows near Mormon Lake, 28 miles south of Flagstaff. When John Nuttall and Erastus Snow passed through in November 1878, they found five families that had produced 5,400 pounds of cheese and 442 pounds of butter from 115 cows. F. A. Ames photographed these Mormon women and children at Mormon Lake around 1888. (National Archives 106-FAA-40B.)

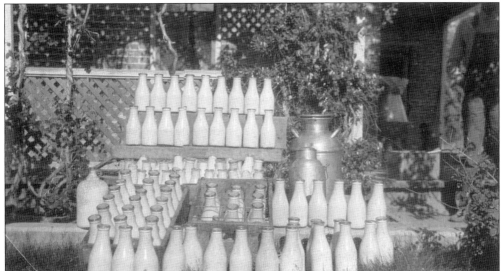

Bread-and-milk was a staple in pioneer diets, and dairies became an important source of income. In 1922, Hiram Sutcliffe began a milk route in Winslow using milk purchased from local farmers. These bottles and milk cans sit on the steps of Joseph C. Hansen's home, presumably to be picked up and delivered to customers in Winslow. (Sarah May Miller.)

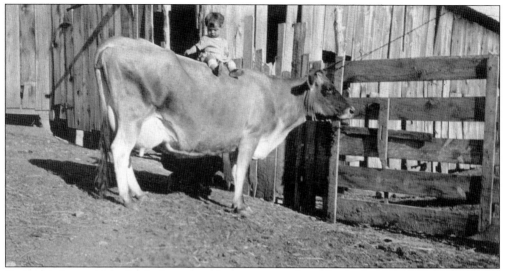

Posing a baby on the back of a farm animal was common (here the shadow below the cow suggests a person holding the baby); other photographs show Vincent Flake on the back of a giant pig and Fost Flake on the back of a prize bull. The name of this baby is forgotten, but the name of the cow is not; Old Betty provided milk for the Levi Shumway family for many years. (Shirley Cole.)

Cows were pastured together outside town, and herd boys were sometimes paid 75¢ per head per month. After World War I, Snowflake tried to outlaw cows wandering the streets, and Tom Tanner, the constable, would put any offending animal in the "stray pen." Pauline Udall Smith (with granddaughters Elaine Church [left] and Janis Smith) is here milking the family cow in front of their residence. (Marion Smith.)

Rivalry between Taylor and Snowflake sports teams is legendary. One ardent booster was Eva Palmer. She achieved her goal of having a basketball team composed only of her sons when the family operated the Service Dairy in Winslow around 1938. During each of her pregnancies, she wrote, "We played baseball. . . . I was on the married women's team," usually catcher. (Renee Hughes.)

Eva Palmer was also responsible for adding the dangerous game of football to high school sports in the 1930s. Moneta Fillerup wrote that in 1936, her son Otho "played varsity football in High School, winning his letter and losing two teeth." In 1963, Eva Palmer (front) accepted Taylor's Hall of Fame award for her husband, Arthur (although her own community service was extensive). Other honorees were Wilson Shumway (son Lyle accepting award, left), Arthur Hancock, Margaret Larson, and Laura Baird Hunt (far right). (Arvin Palmer.)

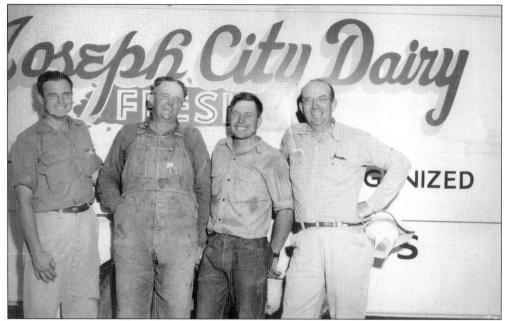

In the 1950s, Joseph City dairymen banded together to form a cooperative, the Joseph City Dairy. Shown here from left to right are Jay Miller, Delbert Hansen, Virgil Bushman, and Bill Gregory (Navajo County extension agent). In 1957, Westover's Guernsey Dairy and Hunt's Homestead Dairy also joined, and the Midway Dairy then delivered milk in both Winslow and Holbrook. (Sarah May Miller.)

Modern convenience came to Joseph City in 1951 when the El Paso Natural Gas Company built a line from the San Juan Basin. Thus pioneer heating and cooking advanced from wood to coal, fuel oil, and butane, and then to natural gas. Chamber of commerce members standing in front of the trencher are, from left to right, V. P. Richards, Delbert Hansen, Clinton Duncan, Roy Payne, and Irene Roberson. (Sarah May Miller.)

Snowflake's Groundhog Day Breakfast began about 1925 with Eugene Flake (right) cooking breakfast for his children—ground hog (pork sausage), biscuits, and gravy. As the children married and as friends and neighbors were invited, cooking and serving moved to the ditch bank. Although the day might be cold and blustery, and long underwear, good coats, and ear muffs were recommended, the meal was cooked in the traditional cattle roundup fashion—a Dutch oven over a campfire. These images are from 1970; below from left to right are Dean and Sanford Flake, Leo McCleve, and Lee McCray. The last Gene Flake breakfast was held in 1971, although family members continued the tradition for a few years. Today the town of Snowflake serves breakfast (beginning at 5:00 a.m.) using city employees, firemen, and volunteers. (Both, photographs by Max Hunt.)

Wilma and Fred Turley operated the Sundown Ranch from 1920 to 1951. To make it profitable, in 1925, they opened their ranch to boys from the East. The first was Larimore ("Larry") Foster from New Jersey. The photograph (above) at the Baca Ranch in Black Canyon was taken in July with, from left to right, Bill Everett on Midnight, Larry on King, Wilma on Stockings, and Fred on Jug. The night before Larry was to return home, he rode alone to see the sunset; his horse spooked, and with his foot caught in the stirrup, he was dragged to death. Larry's parents encouraged the Turleys to continue and also published his journal (*Larry*, 19 reprintings). Many young men came hoping to experience ranch life in the West. Below, Al Levine (seated, right) in 1934 helps Fred Turley hold a calf for branding. (Above, Wanda Smith; below, Louise Levine.)

Brothers Fred and Barr Turley always worked together in the dude ranch business. In 1928, just three years after they began hosting boys from the East, they began a similar ranch for girls. The visitors were treated to a 14-day horseback trip to the Hopi Snake Dance. Here Fred cooks for his guests using a Dutch oven. Later the Turleys added trips to the Grand Canyon and the Gallup Indian Powwow. (Wanda Smith.)

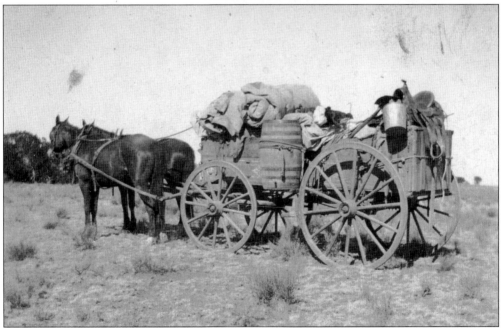

A working cattle ranch often included trailing the cattle from winter to summer pastures. Evans Coleman saved this photograph of a 1903 drive from New Mexico to the White Mountains when 400 head of cattle were moved. The wagon carried food, bedrolls, a 20-gallon barrel of water, an extra saddle, and "small calves that cannot keep up with the herd." (AHS/Tucson No. 71726.)

When the dude ranch horses got too old to be useful, many townspeople kept these gentle horses for their children to ride. Lester Shumway purchased this horse named Twilight, and the children are, from left to right, Dale, Phil, Shirley, Joyce, Ann, Van, and Lenn Shumway. (Shirley Cole.)

With a lifetime of ranching experience, Fred Turley was asked to supervise the LDS Church's registered cattle in Florida, beginning in October 1957 and lasting about a year. One highlight was the visit of Pres. David O. McKay, whose long-standing association with horses at Huntsville, Utah, led to this photograph; the men include, from left to right, Leo Ellsworth, President McKay, Fred Turley, and Henry D. Moyle. (Wanda Smith.)

One of the boys who came to the Turleys' dude ranch was Al Levine from New York City. He came most summers from 1932 to 1936, then returned in 1939 to marry Louise Willis. Levine is shown here on his horse Paleface around 1946, when he worked his own ranch east of Snowflake. He also became a high school biology teacher and published many old Snowflake photographs in two volumes. (Louise Levine.)

Louise Levine is here around 1946 vaccinating a calf for blackleg, a highly fatal disease caused by the bacteria *Clostridium*. In 1921, blackleg decimated the cattle in Navajo County and helped cause a local economic depression. That year, the federal government gave a six-month extension for grazing fees, the Board of Supervisors waived penalties and interest on late taxes, and the county fair was cancelled. (Photograph by Albert Levine.)

These nattily attired, c. 1917 men from the Snowflake area are, from left to right, George A. Smith, Lucien Owens, and Boyd Willis. Such photographs were often taken when young men were working away from home. Willis lived in New Mexico and California. Owens moved to Holbrook, becoming a wholesale gasoline distributor and selling Studebaker automobiles. Smith eventually moved to Phoenix. (NCHS.)

About 1930, Lorum Stratton (right) was working in Mesa. His father, William Ellis Stratton (second from right), was visiting and wanted to return home to Snowflake. Arrangements were made for brothers Lynn (left) and Raymond (second from left) to drive south from Snowflake and for Lorum to drive east and north from Mesa. They met halfway between Whiteriver and Globe at Cassadore Springs, transferred their father and luggage, and returned home. (Lorum Stratton.)

Fred Turley was just 17 years old when the U.S. Forest Service decided in 1913 to build a 115-foot lookout tower at Promontory Butte (photographed in 1920). Telephone crews were working to connect the Coconino and Sitgreaves National Forests so fire reporting could be instantaneous. U.S. Forest Service employees helped peel the poles, but Turley used spikes to climb and lash each additional tier. Promontory Lookout was known as the tallest wooden tower in the United States. (Wanda Smith.)

In 1944, the *Holbrook Tribune-News* reported, "Three of Six Forest Fire Lookouts on Sitgreaves This Season Are Women," one of which was Turley's daughter Wanda (right, with sister Marilyn). The other women were Annis Jackson and Armitta Youis. Two lookouts, using the Azimuth Ring, could provide the exact location of smoke via triangulation. (Wanda Smith.)

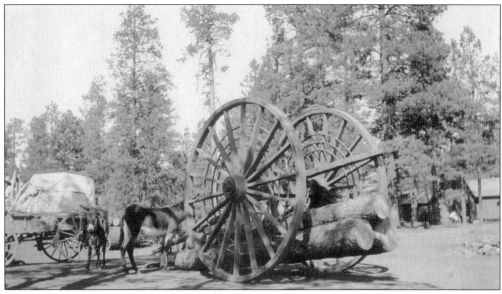

The extensive ponderosa pine forest in the White Mountains provided lumber for homes and also jobs. In 1917, Tom Pollock built a sawmill at McNary. Big-wheel skidders (above) were used to move the logs. After World War I, lumber prices fell and the mill closed. Then in 1923, M. W. Cady and James McNary reopened the sawmill. Bill Gibson and sons moved to McNary to work. (Wanda Smith.)

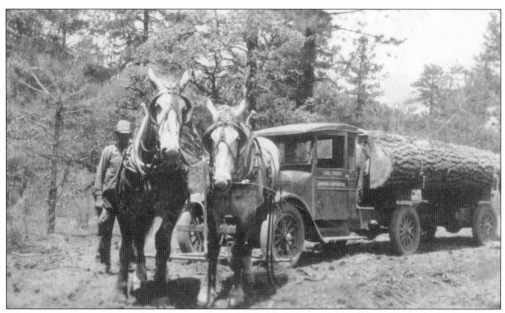

Leo Frost also logged until about 1930, often with his brother Allen (left) and son Richard (behind cab). The men first cleared a corridor for the railroad and built up a roadbed. Richard remembered, "When the railroad was completed, logging would be done out into the forest on both sides." Trucks hauled the logs to the railroad, but horses were used to skid logs to the trucks—and also help the loaded trucks up the hills. (Claudia Sullivan.)

Normally a trucking accident is not a laughing matter, but that was Carl Tanner (above, left), Phyllis Ballard, and Elwin Bushman's response to this unbalanced load at the Holbrook depot in the early 1940s, which left the front wheels spinning in the air. Lawrence Smith began freighting in 1923 at age 19 with team and wagon, bought his first truck in 1932, and in 1939 with David E. Heywood began the Smith-Heywood Company. Freight from Phoenix to all points in Navajo and Apache Counties came by Smith-Heywood trucks until the company was sold in 1964 to Thunderbird Freight. Back-haul of White Mountain lumber contributed to the growth of Phoenix. When U.S. Highway 60 connected Show Low and Globe in 1936, Smith-Heywood drivers would begin in the White Mountains and Phoenix, then trade trucks halfway through the trip; Carl Tanner was the Phoenix-based driver for many years. (Both, Lilia Seegmiller.)

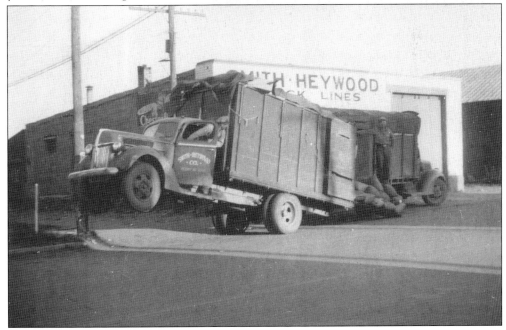

After World War II, Emil Pooley, a Hopi, was married and living in Winslow. He and his family joined the Mormon Church, and, with a Navajo wife and Mormon affiliation, he felt it best to move to Joseph City. Here he supported his family by carving Kachinas, also known by Native Americans as Katsinas, even though he had earlier lost part of one hand in a railroad accident. (Esther Stant.)

Construction was always a good source of income. This summer 1941 photograph is of a survey crew for the U.S. Bureau of Reclamation. The men are identified only by first name, from left to right: Ray, Frosty, Perk, Marsh, Max (Hunt), and Quil. (Photograph by Max Hunt.)

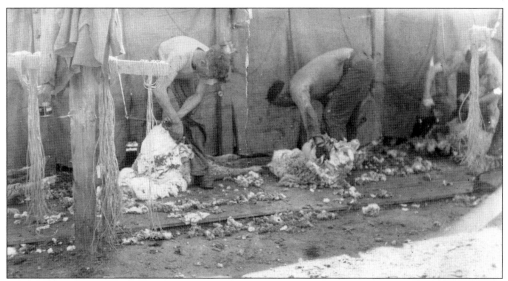

Many men sheared sheep each year to earn outside income. Joseph Fish noted that, in the warmer climate of Arizona, sheep ranchers sometimes sheared "twice a year, or rather most of them shear twice one year and then on[c]e the next." This image is of Noble Rogers (left) in a shearing shed near Wickenburg around 1928. (AHS/Tucson No. 6-4277.)

The Arizona State Cowbelles were first organized in 1939 by women in Douglas (with groups in Wyoming and Texas organized in 1940). Cowbelles promote the beef industry; today there are 16 groups in Arizona. In the 1940s, women from Flagstaff (wearing nametags) joined Navajo County Cowbelles Lena Randall (seated second from left), Margaret Bourdon (seated second from right), and Pearl Willis (standing fourth from left) for a meeting. (Roma Lee Hiatt.)

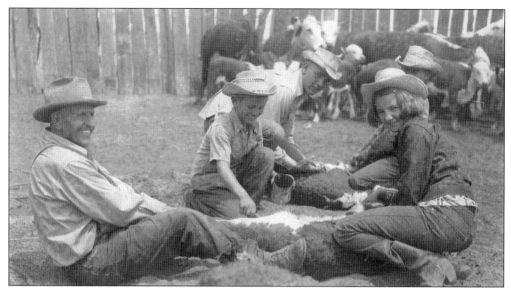

Early cattle were Durhams and mixed breeds, but northern Arizona ranchers soon changed to Herefords. In 1953, Don Dedera photographed the Flake family working their cattle; from left to right are Ab, Steve, Jake, Cleone, and Jeddy. Jake is vaccinating and Steve is swabbing the cuts to prevent blowfly infestation. (Cleone Solomon.)

Jake Flake continues the William J. Flake cattle ranching tradition. The Flakes now run Beefmaster cattle, seen with a granddaughter, Tyler Ann Flake, in the saddle. Although the family continues to be active ranchers, many people from Snowflake undoubtedly would echo Kenner Kartchner's feelings: "As a retiree in urban surroundings, the things I miss most are a good horse, a well-fitted saddle, the soft jingle of spurs, [and] the jog-trot cadence along a mountain trail." (Photograph by Florine Duffield.)

Four

CHANGES

Hy Hendrickson served as a chaplain in the South Pacific during World War II. In 1979, he was asked to speak at a 24th of July celebration. He chose to honor those who had given their lives during the war and said, "I saw a force of men with dedication and purpose. They believed in America, they believed in the freedom they were fighting to preserve. They believed in preserving the blessings we take so for-granted in this country."

War was not the only vehicle of change in these Mormon communities. Many men left for employment and only some returned. "My brothers and I were raised in Flagstaff," wrote Lori Gibson Gill recently, "but we always spent lots of time with our grandparents in Snowflake and Taylor. Since my husband is in the Army, we cling to the familiarity of Snowflake as 'home' since we have family there. It's hard to know where home is sometimes."

In the 1960s, Southwest Forest Industries built a pulp and paper mill west of Snowflake, and Arizona Public Service built Cholla Power Plant east of Joseph City. Finally there was employment that would sustain growth, and these early pioneer communities would persist.

Upon the death of William Jordan Flake in 1932, Gov. George W. P. Hunt wrote, "He was one of Arizona's most distinguished and honored Pioneer citizens. To men and women of his pioneer type, our State owes a heavy debt of gratitude for their courage, faith and industry, which laid the foundation for our present day civilization in the west." Larry Foster, although only in Arizona a brief summer, summed up the contributions of every pioneer:

> In honor of undaunted pioneers
> Who strove, endured, and died, to make this land;
> Of red men, fast decreasing through the years;
> Of cowmen who are making their last stand;
> Of ranchers who have learned to love a home;
> Of lumbermen who make the forests ring;
> Of punchers, rangers, herders—all who roam—
> Of *folk* in Arizona's hills, I sing.

Mormon/Native American relationships were complex. Before coming to Snowflake, Bishop John Hunt lived in Savoya, New Mexico, where many settlers contracted smallpox and Samantha Brimhall died. Both the Hunt and Brimhall families were grateful for wild game provided by a Navajo man. Although he was possibly the same man, the Brimhalls remember him as Chief Josephine (Joseph of the Pines) and the Hunts as Charlie. These pictographs were chalked and photographed by Al Levine around 1980 with son Charles giving perspective. (Louise Levine.)

Sarah Harrop died during childbirth in Snowflake/Taylor in 1880. She was a Ute adopted by the Benson family in Parowan, Utah, who married Englishman Henry Harrop. She left seven little children, including Emma Lauretta, age seven. Three years later, Henry remarried, and, with his extreme poverty and a move to Mesa, "Retta" was left with the William Solomon family. At age 16 (left), she married William Morgan from Show Low. (Shirley Cole.)

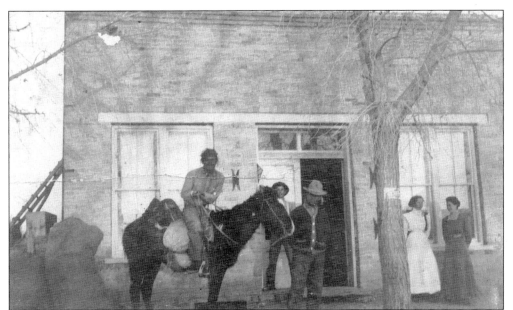

Joseph City, with its proximity to Hopi and Navajo reservations, had many Native Americans come to trade (here in front of John Bushman's store). Max Hunt remembered the Navajos "driving their cattle into town and selling them to Uncle Ez[ra Richards]. They were separated from their calves [at the corrals behind the house] and the cows and calves would bawl all night." (Wanda Smith.)

Preston Bushman grew up at Joseph City, and, as Jack Frost recently stated, "We all knew a little Navajo." As an adult, Bushman lived and ranched at Dry Lake (Zeniff). This photograph is labeled "Preston Bushman and friend," presumably Hopi. (AHS/Tucson No. 6589.)

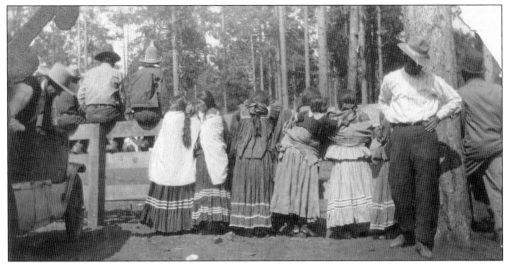

Apaches often came for rodeos (here probably in the White Mountains). Albert Levine told of some attending the rodeo and a pageant that included covered wagons being attacked by "Indians." Levine said, "A couple of Apache boys were sitting on a limb of one of the cottonwood trees and got to laughing so hard at the make believe Indians that they almost fell off of the limb." (Leola Leavitt.)

Jacob Hamblin first came as a missionary to the Navajos and Hopis in 1858. A sample of other missionaries includes Martin D. Bushman (25 years part-time), David Flake (full-time, 1958–1960), and Bud and Betty Hunt (weekends at Leupp 1988–1990). Fred and Wilma Turley (above, center) presided over the Southwest Indian Mission from 1958 to 1961 and hosted a visit by Pres. Spencer W. Kimball (left of Wilma) when they had five Navajo elders. (Wanda Smith.)

In the late 1950s, when the federal government began placing Navajo students in dorms off the reservation, temporary housing was placed south of the football field in Snowflake. The mostly self-segregated nature of the interactions between students can be seen in this photograph of Navajo parents visiting for a school graduation or program. (Photograph by Max Hunt.)

Robert Yellowhair, a Navajo but Zuni by ancestry, came to Snowflake in 1964 and has made his living as a butcher (for Nephi Bushman), rodeo roper (for 25 years), saddle maker, belt-buckle silversmith, and painter. His favorite painting is the temple-apple painting; the apple represents Yellowhair today, "Red on the outside, white on the inside."

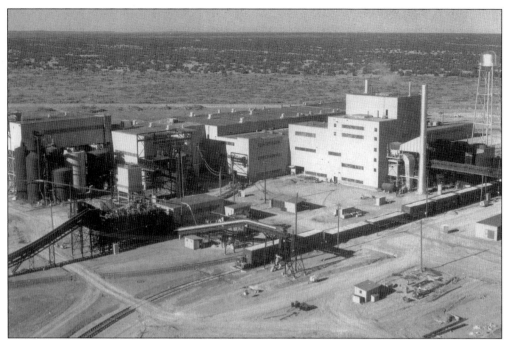

In 1956, Southwest Forest Industries entered into talks with the Aztec Land and Cattle Company for land west of Snowflake to build a pulp and paper mill. Development of the industry depended upon adequate water, found with five test wells. Construction began in August 1960 (shown above in early 1961); the mill was completed in 15 months at a cost of $32.5 million. The photograph below, taken in October 1961, shows chip storage at lower left and pulpwood storage at lower right. Initially the paper mill produced 75,000 tons of newsprint and 65,000 tons of kraft linerboard annually. Grocery bag construction was added in 1962. (Both, Taylor Museum.)

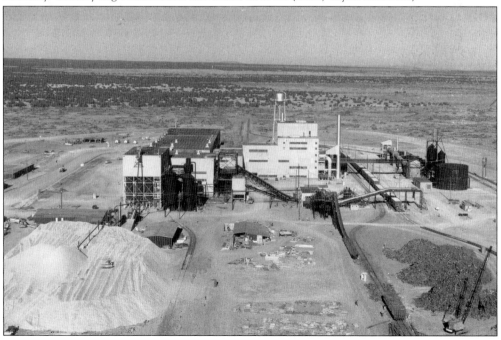

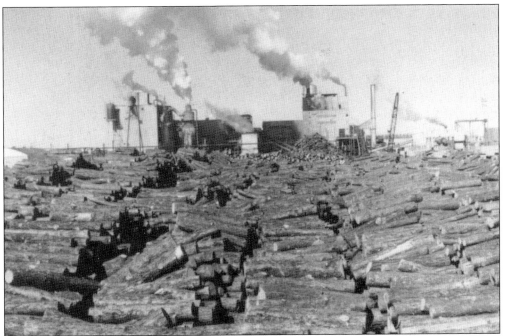

Logs came into the paper mill both by rail and by truck in the late 1960s. The plant is now owned by Abitibi Consolidated. In 1999, it was converted to use 100-percent recycled fibers, about 50,000 tons each month, half of which comes from sources in Arizona. Not only does recycling save landfill space, but each ton saves 17 trees. Additionally, wastewater is now used to irrigate 3,100 acres of alfalfa, corn, and sorghum. (Photograph by Max Hunt.)

The paper making process is centuries old. Today recycled stock is first cleaned of contaminants (trash and ink), and then the fibers go through a slurry, wire, press, and drying process. Each stage removes water from the pulp. Three high-speed paper machines produce the end product, and the rolls are cut to customer size, wrapped, and shipped. This process was illustrated with a float in Snowflake's 24th of July parade around 1970. (Photograph by Max Hunt.)

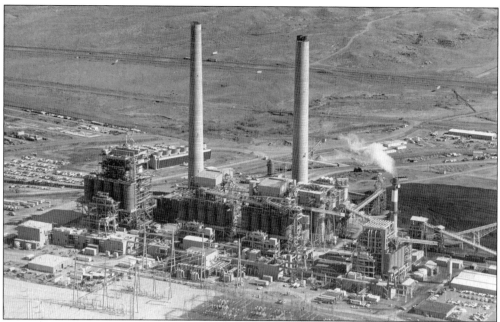

The economies of Holbrook and Joseph City changed when Arizona Public Service built a power plant between the two communities. Cholla Power Plant began transmitting electricity in 1962 from Unit 1; Units 2–4 were added from 1978 to 1981. This 995-megawatt plant uses coal from the McKinley Mine in New Mexico and currently participates in a seasonal exchange with the Pacific Northwest. PacificCorp (actual owner of Unit 4) receives electricity from Arizona in the winter and sends electricity to Arizona in the summer (peak season for each area). The photograph above is of the plant before Unit 4 was added; below, Ted McNabb is photographed in the powerhouse. He worked at Cholla from 1968 to 2002, beginning as a janitor and ending as shift supervisor. (Both, NCHS.)

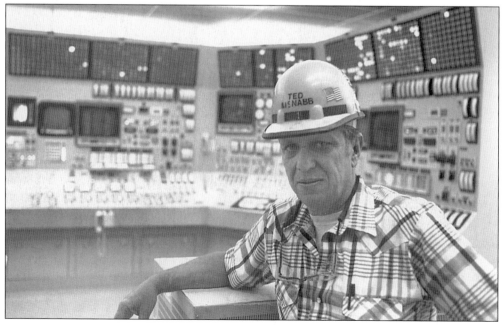

Virginia Evers of Taylor, designer of the Precious Feet pin promoting the Right to Life cause, wrote for the *Grit*, "Where else in America can high school madrigals, made up largely of Mormon students led by the Baptist director sing a Latin midnight mass at the local Catholic church?" Catholics first worshipped at a small chapel at the home of Jovita Gonzales. In 2007, children (above) at Our Lady of the Snow Catholic Church receive First Reconciliation on Good Shepherd Sunday. (Our Lady of the Snow Catholic Church.)

In 1950, Woodruff still did not have a chapel. Morjorie Lupher wrote that in 1951, "the men of the town borrowed a block machine, procured cinders and cement, and made 13,000 blocks for construction." With work mostly donated by locals, the building was completed in 1957. Church leaders in 1958 included, from left to right, Bishop Melvin Gardner, Laurice Hatch, A. L. ("Tony") Johnson, and LeGrande Turley. (Photograph by Max Hunt.)

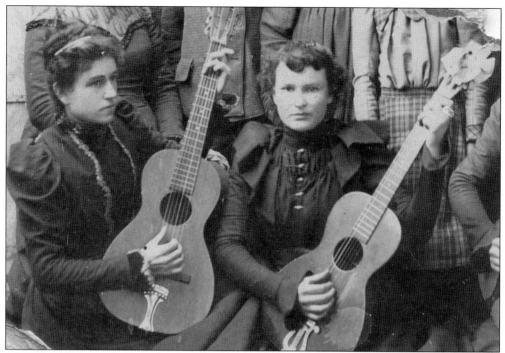

From the beginning, music has played an important part in each of these communities. This partial photograph of Jesse N. and Janet Johnson Smith's children shows daughters Priscilla (left) and Ruth with their guitars. In the full photograph, their sister Margaret is also holding a guitar. (Smith Memorial Home.)

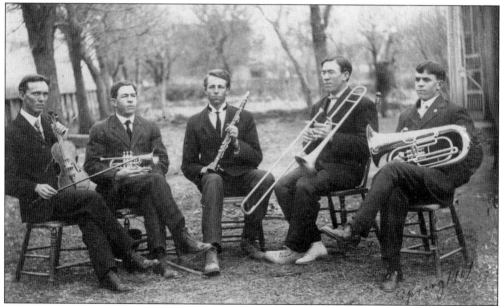

All sons of original Joseph City pioneers, these young men posed for a spring 1909 photograph. The band included, from left to right, Thomas Shelley, J. Virgil Bushman, James Hansen, Alonzo Bushman, and Fred Bushman. They all married shortly after this photograph and went their separate ways for employment. (Leon Miller.)

Each year at Taylor's Fourth of July parade, this drum (shown with the children of Carl and Shirley Cole) leads the parade. It was used by Maj. Edward Duzette in the 1840s Nauvoo Legion, carried across the plains by Mormon pioneers, and then brought to Taylor by Cyrus Jennings. Rhoda Wakefield wrote, "Happy faces full of gladness like one big family had come / Just to hear some right good music, when Cyrus Jennings beat the drum." (Shirley Cole.)

Lenn Shumway (far right, white jacket), a grandson of Cyrus Jennings, continues to lead the band each Fourth of July (here in the late 1960s). They usually ride on a flatbed truck or trailer to accommodate the violins. Today about half of the "band" are descendants of Jennings, many of whom come long distances just to participate in the celebration. (Carmen Shumway.)

Originally from Joseph City, Laverne Richards Crandell taught first grade in Snowflake for 30 years. She also taught beginning piano students. She married J. Rufus Crandell, an excellent violinist and string teacher, and they provided music for nearly every funeral and church service in Snowflake and the surrounding communities. (Photograph by Max Hunt.)

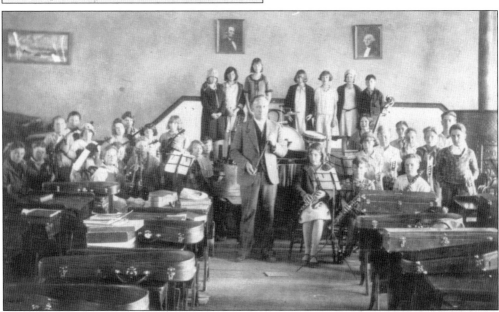

Rufus Crandell taught enough students to play violin, viola, cello, and bass that an orchestra was always part of the school curriculum (photograph, c. 1932). Although most became violinists, when a bass or cello player was needed, the next aspiring string student would be talked into beginning that instrument. Crandell's pioneer heritage is remembered in his oft repeated adage, "He who chops his own wood gets warm twice." (Wanda Smith.)

After many short-lived choruses and orchestras, the Silver Creek Symphony was organized in 1979 with Blair Clawson as its first conductor (above). Clawson stated that his Northern Arizona University professor "was amazed that a small, rural farming community would have the musical resources to mount any significant ongoing community orchestra, much less one operating on such a high musical level." At the 25th anniversary celebration, May 7, 2005, (below), Anna McCleve photographed others instrumental in founding the orchestra: from left to right, Wilna and Melvin DeWitt (orchestra teacher), Clawson, Lenn Shumway (band teacher) and his wife, Carmen. (Both, Anna McCleve.)

Past conductors were also honored at the 25th anniversary concert. Above, from left to right, Clarence Shaw, Blair Clawson, Lenn Shumway, and Alan Beste receive accolades from Dawn Edgmon (symphony president) and symphony members. Below, the White Mountain Regional Symphony Orchestra, as it is known today, is photographed with the current conductor, Benjamin Shoening. Musicians come from as far away as Gallup, New Mexico, to rehearse and play with the symphony, and all who participate understand Blair Clawson's thoughts: "It fulfilled a lifelong dream the first time I stood on the podium, dropped a downbeat, and heard the waves of beautiful sound that came in response." (Above, photograph by Martin Jackson; below, Anna McCleve.)

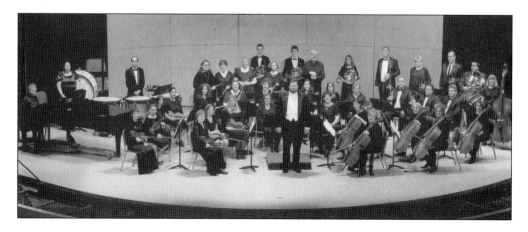

John and Evelyn Taylor with daughter Lynn Johnson stand beside Snowflake's Pioneer Monument, dedicated July 21, 2000. Johnson helped spearhead the campaign to build the monument and is a direct descendant of William J. Flake. To commemorate a meeting along the trail near Winslow where the new settlement was named Snow-Flake, sculptor Justin Fairbanks created freestanding figures of Lucy Flake (holding daughter Roberta), William J. Flake, and Erastus Snow; the frieze includes Jesse N. Smith (left), John Nuttall, and Ira Hinkley (obscured).

Taylor's Fourth of July celebration begins with the firing of the anvil, a tribute to early blacksmiths. An anvil that belonged to Quill Standifird is placed on the ground, then a sledgehammer head is used for the core, and Joseph Smith Hancock's anvil is on top. The loud boom is produced by lighting the powder in the core with a hot piece of metal attached to a long pole. (Carmen Shumway.)

Unique to Mormon communities is a 24th of July celebration (with parades and rodeos) to commemorate the 1847 entrance of pioneers to the Salt Lake Valley. In 1941, Al Levine created a Hopi/Zuni shalako for the parade. As Levine walked inside, he could operate the snapping, clacking beak with a string. These 12-foot-tall katsinas dance during the winter solstice to give thanks for good harvests and to invoke blessings on newly built houses. (Louise Levine.)

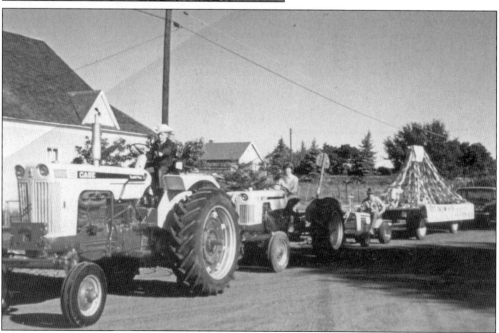

In the mid-1960s, Roy Palmer, a farm equipment dealer in Taylor, created this parade entry to advertise his wares. On the big tractor is his nine-year-old son, Fred; his daughter Sybil is on the medium-sized tractor; Roy is on the garden tractor; and a toy tractor is on the trailer under the streamers. (Arvin Palmer.)

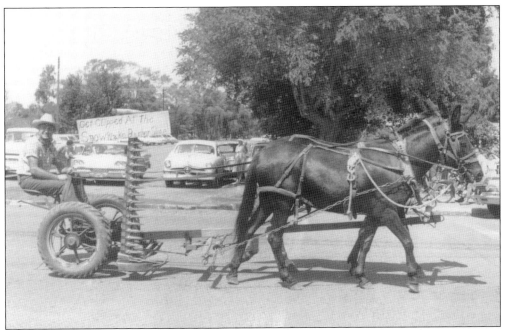

One memorable entry for Snowflake's 24th of July parade during the 1960s was barber Vance Rogers riding a mowing machine with the sign, "Get Clipped at the Snowflake Barber Shop." The price of a haircut, however, also included literature and a sermon on the John Birch Society. (Photograph by Max Hunt.)

Early Snowflake Pioneer Day celebrations also included boxing. These 1938 boxers are unidentified, but Stan Turley told of a melee at St. Johns about that year after a football game. Turley stated, "We had a couple of good boxers, Gerald Pace and Ralph Merrill"; St. Johns "beat us in the game, but we beat them in the fight, so guess it was about a draw." (Photograph by Max Hunt.)

Horse racing was a common activity in Snowflake, especially down Back Street. Here Samuel H. Smith (left) and Louis Johnson fly down the street at an unknown date. However, betting on the races was discouraged. In 1890, Charles and James Flake were called before the high council, and, according to Joseph Fish, "This little affair of horse racing and betting . . . led the council to take a strong stand against betting." (Sarah May Miller.)

Summer celebrations in ranching communities often include a rodeo. Many participants today are professional cowboys in the rodeo circuit. In the past, local cattlemen and women competed to demonstrate their prowess. Here in 1964 is the father/daughter roping team of Linford and Sherry Webb. They competed for a decade and were particularly noted because they were a father/daughter, not a father/son, team. (Photograph by Max Hunt.)

Rodeos usually include children's events, such as a Mutton Bustin' contest with a sheep being ridden instead of a bull. Day and Nola Ellsworth may have raised Taylor's Youngest Bull Rider (or Taylor's Youngest Bull Ridden) when two-and-a-half-year-old Anthony insisted on riding a day-old bull calf. Here around 2000, a goat with money attached gives the children a chance to "earn" a little cash. (Shirley Cole.)

Cody Hancock of Taylor won the World Bull Riding Championship in 2000 and holds the Wrangler National Finals Rodeo (NFR) high-point arena record (96-point ride). He comes from a family of cowboys; his great-grandfather, Art Hancock, was foreman of the Bourdon Ranch, and his father, Ray, rode bulls (senior division) until 2006. Cody Hancock says, "It's an endurance thing. You've got to keep your head up and try hard on every bull."

Overseeing the religious education of pre-teen children in Mormon communities is a Stake Primary presidency. In the late 1950s, this included (above, from left to right) Lora Morris, Venola Lancaster, Leonora Hansen, Beulah Hunt, and Pearl Solomon. A common Fourth or 24th of July activity for children was a "Round the Block Parade," shown below in front of the Snowflake Main Street church. Pioneers were often honored with girls in bonnets and little red wagons becoming covered wagons. This parade, however, appears to have a patriotic theme, although flag etiquette seems compromised with the Arizona state flag being carried upside down. (Both, Ralph Lancaster.)

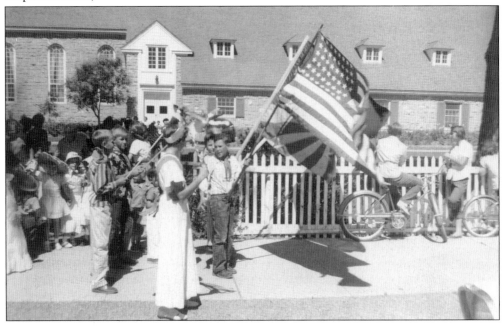

The crowning event for northeastern Arizona's Mormon communities came in 2002 with the dedication of a temple in Snowflake. Only the second temple in the state of Arizona, this sacred edifice serves approximately 35,000 people living in northeastern Arizona and northwestern New Mexico. The temple stands on a small hill, and its spire, topped by the traditional angel, can be seen for miles. A beautiful waterfall made from native red sandstone marks the entrance. Couples no longer have to make the trip to St. George, Salt Lake City, or even Mesa to be married in a temple.

ACROSS AMERICA, PEOPLE ARE DISCOVERING
SOMETHING WONDERFUL. *THEIR HERITAGE.*

Arcadia Publishing is the leading local history publisher in the United States. With more than 4,000 titles in print and hundreds of new titles released every year, Arcadia has extensive specialized experience chronicling the history of communities and celebrating America's hidden stories, bringing to life the people, places, and events from the past. To discover the history of other communities across the nation, please visit:

www.arcadiapublishing.com

Customized search tools allow you to find regional history books about the town where you grew up, the cities where your friends and family live, the town where your parents met, or even that retirement spot you've been dreaming about.